IMAGES
of America

LOUISVILLE'S GERMANTOWN AND SCHNITZELBURG

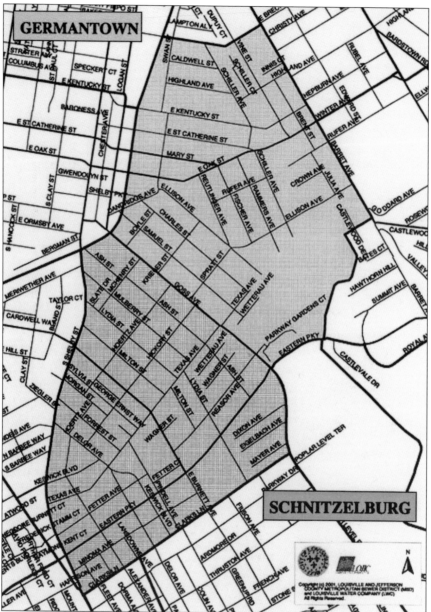

This map shows the current boundaries of Germantown and Schnitzelburg. Older maps of Louisville show branches of Beargrass Creek winding through both communities. Flooding, ponding, and general marshy conditions led to calling Germantown "frogtown" in the early days. Limited development and isolation of some parts of the community resulted. Later man-made changes to these tributaries allowed for the expansion and growth of Germantown and Schnitzelburg's boundaries as we see them today. (Courtesy of the Louisville/Jefferson County Information Consortium.)

ON THE COVER: Members of the Altes Deutche Band were residents of Germantown and Schnitzelburg in the early 1900s. They played concerts and weddings and gave serenades on Valentine's Day. (Courtesy of Don and Janice Haag.)

IMAGES
3 *America*

LOUISVILLE'S GERMANTOWN AND SCHNITZELBURG

Lisa M. Pisterman

ARCADIA
PUBLISHING

Published by Arcadia Publishing
Charleston, South Carolina

Printed in the United States of America

Library of Congress Control Number: 2010929322

For all general information, please contact Arcadia Publishing:
Telephone 843-853-2070
Fax 843-853-0044
E-mail sales@arcadiapublishing.com
For customer service and orders:
Toll-Free 1-888-313-2665

Visit us on the Internet at www.arcadiapublishing.com

To all the wonderful acquaintances I have made in the course of putting this book together and everyone who shared their family stories with me.

CONTENTS

FOREWORD

One of Louisville's most stable and traditional blue-collar neighborhoods, Germantown retains a bit of German character to this day, and it shows not only in the parishes of St. Thérèse and St. Elizabeth but also in the neighborhood's remarkable collection of small, family-run beer bars that seem to inhabit almost every corner, each with its own band of loyal partisans.

So many German-speaking immigrants came to Louisville during the middle years of the 19th century that the city of those days might have had a bit of the feeling of Munich or Bonn. Seeking freedom in America and relief from political upheaval in the Fatherland, they followed earlier migrants who'd come down the Ohio from Pennsylvania and Virginia, built large Catholic churches, and settled around them.

By the time of the Civil War, the latest wave of immigrants moved into rows of small, trim frame houses on a neat grid of streets in a section south of Broadway along Goss Avenue and Beargrass Creek, turning what had been rolling dairy farmland into the neighborhoods we now call Germantown and Schnitzelburg.

—Robin Garr
Louisville writer and critic

ACKNOWLEDGMENTS

Many thanks to the following individuals and families for their invaluable help and time and their passion for the history of our Germantown, Schnitzelburg, and Germantown-Paristown communities: Don and Jan Haag, David Pisterman, Steve Magre, the Gnadinger family, George Hauck, the Lee family, Carroll Ray Obst, John Booker, Ed Hulsman, Ron Schildknect, Fr. Dale Cieslik, Regina Herdt, the Geisburg family, Tammy Jones-Scrogham, Anna Dale Ernst, Mary Bond, Dorothy Speier, Kevin Katz, Carol Russman, Ron Hildenbrand, Steve and Sue-Sue Hartstern, Steve Cambron, Danny McMahan, Bill Tinker, Margie Drane Hoferkamp and family, Marife Bautista, the Murrow family, the Osting family, Tom Owen, Valerie Moberly, and Sadie Hartlege. A thousand thanks to my editor, Amy Perryman, for her expert guidance.

INTRODUCTION

Ethnically defined communities exist throughout the United States, including settlements called "Germantown" in Tennessee, Maryland, Wisconsin, New York, Ohio, and Pennsylvania, to name a few. Common bonds of language and religious beliefs bound the residents of Louisville's early German community and eased the difficulty of transition to a new country. New German arrivals in Louisville settled across Broadway in Butchertown and further to the west in downtown Louisville. In 1851, property long tied up in probate court was released from the conditions of sale outlined under the will of Alexander Campbell. Mary Campbell Beard, for whom Mary Street is named, sold her interest in this property, which was quickly purchased by the German newcomers for homes and businesses. The small lots were affordable, and there was room for gardens and dairies. During this time, expansion was limited by the winding fork of Beargrass creek. The county's largest watershed, spanning 60 square miles, ebbed and flowed and flooded parts of Germantown and Schnitzelburg, sometimes with disastrous consequences. The creek kept growth in parts of Germantown and Schnitzelburg to a minimum, but by the turn of the century, Beargrass Creek was engineered in order to control flooding and allow for further development.

The boundaries of the area known as Germantown have gradually expanded since the 1850s, but the boundaries of Schnitzelburg have always been fairly defined by the trolley loop that circled the community. Both Germantown and Schnitzelburg have always been held as the standard for neat, immaculate cottages, maintained with old-world care and pride. Homes range in date from the 1880s to the 1920s, the shotgun and camelback being the most common styles in a neighborhood. The streets were also dotted with storefronts that included residential space on the second floor. The shotgun style of home has one long central hall from front to back that, theoretically, would enable one to fire a shot straight through the front door and out the back door. The long central hallway with transoms made for very efficient ventilation through the homes. Camelback homes feature two additional second-floor rooms on the back of the house. The construction of shotgun houses slowed and eventually stopped during the early 20th century. Because of Germantown and Schnitzelburg, Louisville continues to be recognized as one of the few American cities with such a large remaining collection of these unique historical homes.

One

BUSINESS

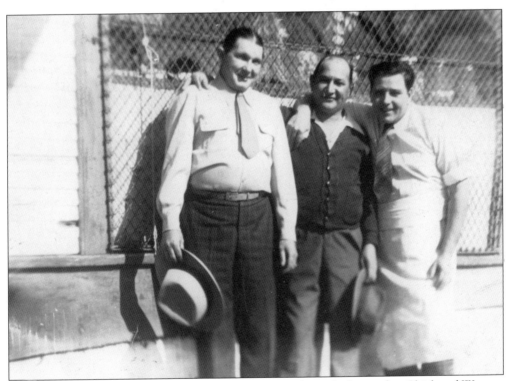

Chester W. "Check" Sumser (left) is pictured in 1947 with regular bartenders Chick and Warren. Check Sumser opened Check's Place at 1101 East Burnett Street in 1940. Like his father, Check had been a housepainter by trade, then became a clerk at Biffi's Cafe in 1938, and finally tried out the tavern business on his own. (Courtesy of Valerie Moberly.)

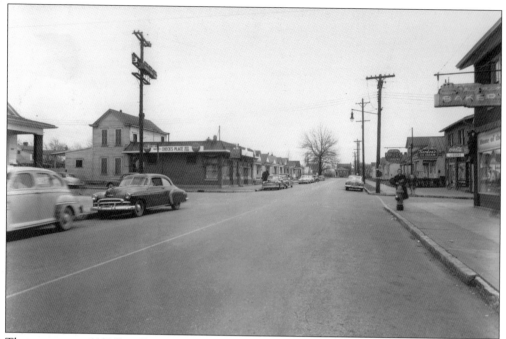

The property at 1101 East Burnett Avenue was built in 1911. In 1928, it was a Quaker Maid, the predecessor of the A&P store. Until Check opened his restaurant in 1940, it had been operating as an A&P grocery store. (Courtesy of the University of Louisville Photographic Archives.)

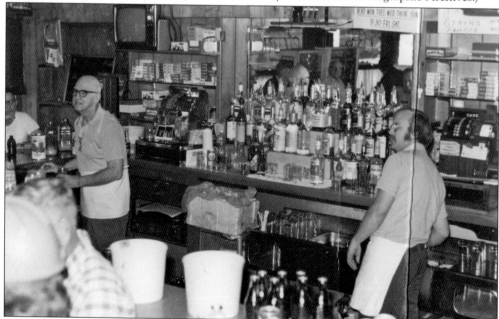

In 1944, Joseph Murrow and Raymond "Barney" Dillman purchased the business from Check Sumser. When Joe enlisted in the army during World War II, brother-in-law Theodore Von Bokern stepped in to help the run the family business. In this photograph, owner Joe Murrow (left) and longtime bartender Tony Ernst (right) serve friends and regulars on a busy Saturday night. (Courtesy of the Murrow family.)

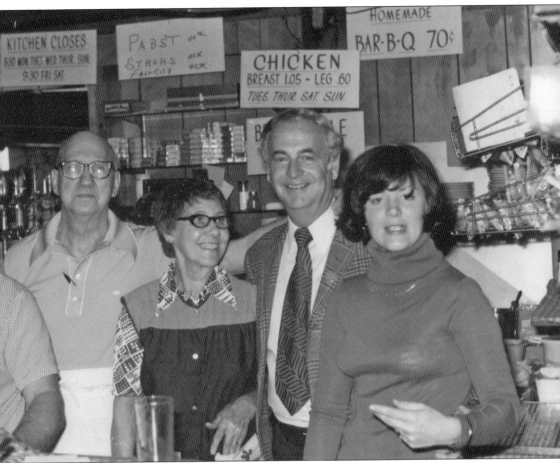

From left to right, Joe Murrow and his wife, Mary, are shown here with Louisville mayor William Stansbury and Sherry Murrow. Check's walls are covered with photographs of family and friends and even photographs of the occasional celebrity visit. Joe made an indelible mark on the Schnitzelburg community and was known for his work ethic, kindness, and generosity to those in need. His family continues to uphold those values in the operation of the business today. (Courtesy of the Murrow family.)

Jacob Heitzman, a native of Hausach, Baden, Germany, immigrated to the United States in 1885, and in 1891, he opened a bakery in Louisville at 608 Baxter Avenue. (Courtesy of the Osting family.)

The second Heitzman bakery shop was located at 1036 East Burnett Avenue in 1933. Son Charles Heitzman would create a niche in an area full of neighborhood bakeries by offering customers intricately decorated cakes for weddings and birthdays and butter kuchen. His expertise would win awards in baking contests and make Heitzman's bakery a household name in Germantown and Schnitzelburg. (Courtesy of the University of Louisville Photographic Archives.)

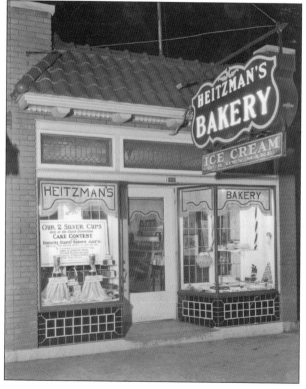

The bakery began construction in 1923 and opened on November 7, 1924. Charles built the large building, but he retained only a small portion for his business, renting out the remainder of the building. Heitzman's bakery business would continue to grow and would in time implement the entire building. (Courtesy of the University of Louisville Photographic Archives)

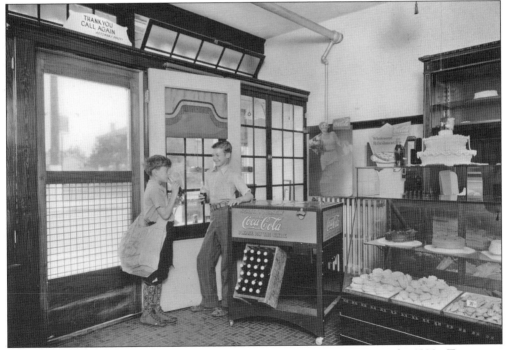

This photograph shows the interior of Heitzman's Burnett Avenue store in the 1930s. Two young customers enjoy after-school sodas and fresh baked goods. The young man on the left is carrying a newspaper delivery bag. (Courtesy of University of Louisville Photographic Archives.)

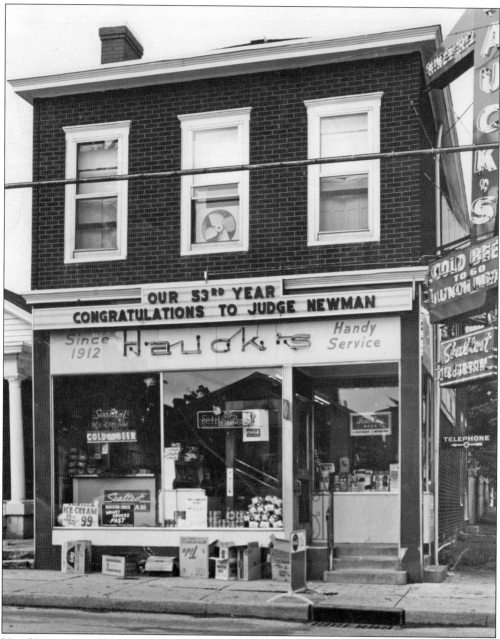

Hauck's is pictured here in 1965 at 1000 Goss Avenue. Founded in 1912, Hauck's Handy Store is still one of the most durable and lasting family businesses in the community. (Courtesy of George Hauck and family.)

Victorian beauty Elizabeth Sprenger Hauck, one of the first woman entrepreneurs in Schnitzelburg, is pictured in this 1901 photograph. Elizabeth and her husband, William, began the operation as a dry goods store, expanding to two additional stores along the streetcar line. The stock of dry goods and notions gradually shifted to milk, bread, butter, candy, and soda, until the store became more of a grocery. (Courtesy of George Hauck and family.)

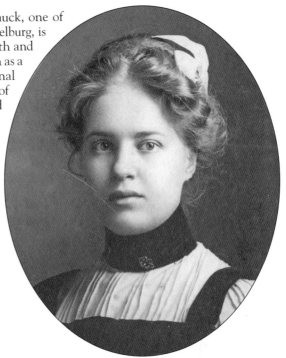

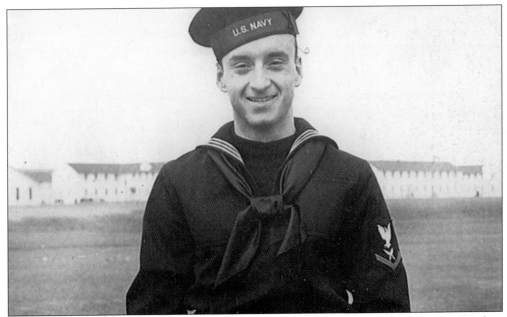

Elizabeth Hauck's son, George, enlisted in the navy three weeks after the attack on Pearl Harbor. His father, William Hauck, died in 1939. Upon completion of his service in 1946, George returned to Louisville and assumed his mother's role in the day-to-day operations of the store. Although Elizabeth had officially "retired," she would be a continuous presence at the store until her death. George made an indelible mark on the community not only as a business owner but by bringing the World Dainty Contest to Germantown and Schnitzelburg and the annual Schnitzelburg Number One Citizens Award Dinner. (Courtesy of George Hauck and family.)

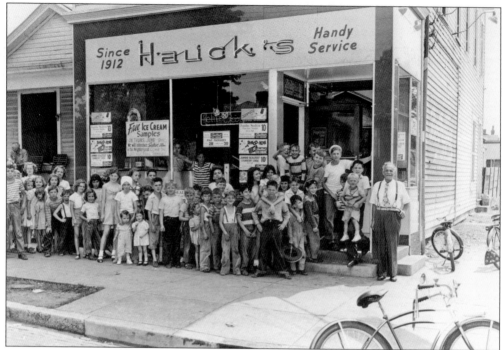

Excited children line up at Hauck's on a hot summer day in June 1949 to try a free sample of Sealtest ice cream. In 1984, George Hauck would invite the children in this photograph back to Hauck's for a reunion celebration. (Courtesy of George Hauck and family.)

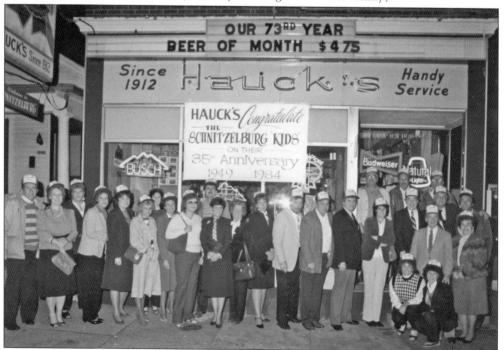

This reunion photograph of the "ice cream children" shows George Hauck (far right) in 1984. (Courtesy of George Hauck and family.)

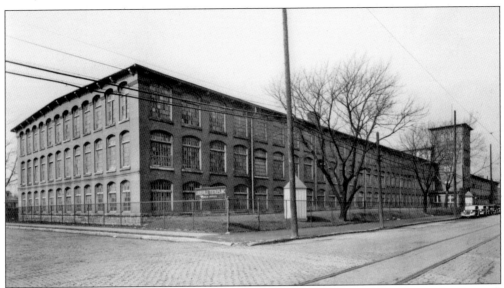

The Louisville Cotton Mill, located on Goss Avenue, has the distinction of being the first mill in Germantown and is a significant example of Victorian industrial architecture. The mill was built in 1888 by Richard A. Robinson, a drug company sales representative, and his son, William Robinson, was the first president of the mill. Architect Charles Julian Clarke designed the main building with its impressive five-story tower. The Louisville Cotton Mill produced cotton warp for the manufacture of Kentucky Jeans. (Courtesy of the University of Louisville Photographic Archives.)

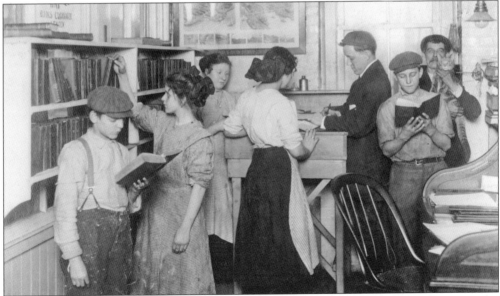

Children made up a portion of the workforce in the early years of the cotton mill. Children attended school to sixth grade, after which time they could obtain a certificate and go to work at the mill. In this photograph, children browse books on library day at the cotton mill. The Louisville Free Public Library established branches in local factories throughout the city. On the back wall, an advertisement hangs for New York and Boston Dyewood Company, a manufacturer of extracts used for dyeing textiles. (Courtesy of University of Louisville Photographic Archives.)

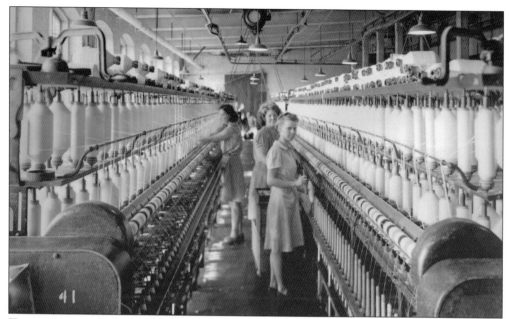

Two women and a young girl work in the long aisles containing ring spinning frames. These frames spun fibers, such a cotton, to make yarn. (Courtesy of University of Louisville Photographic Archives.)

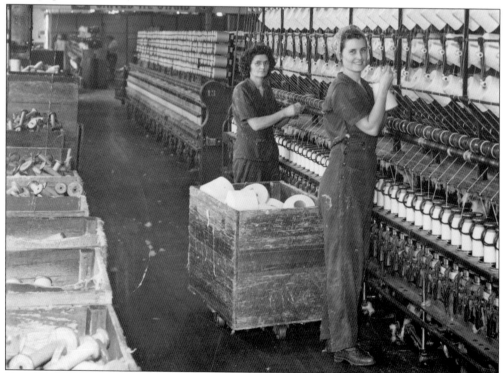

Cora McGaha (foreground) and Betty Bickett are reeling and tying up ends on one of the twisters. Employment during this period reached about 800. (Courtesy of University of Louisville Photographic Archives.)

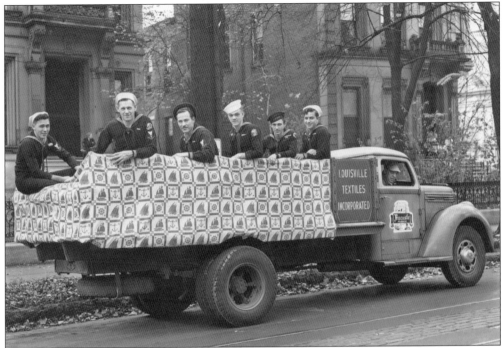

Six sailors ride aboard a truck covered in a nautical pattern of Fincastle fabric in this 1946 parade photograph. (Courtesy of University of Louisville Photographic Archives.)

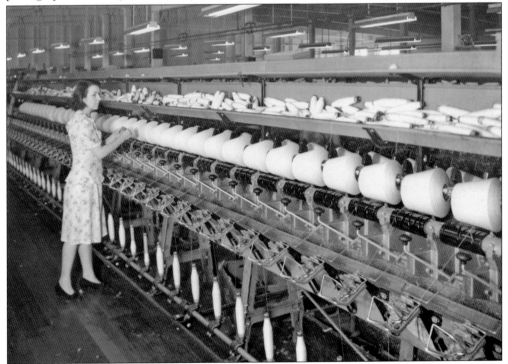

A mill employee tends one of the spinning machines in this early 1940s photograph. (Courtesy of University of Louisville Photographic Archives.)

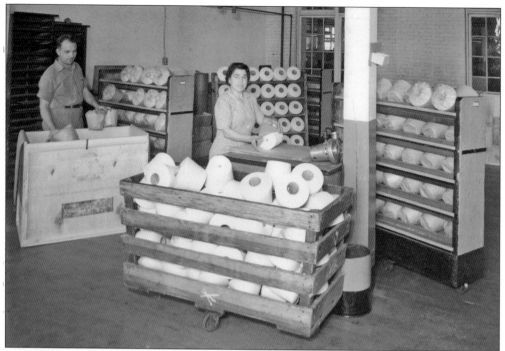

Workers carefully wrapped large spools of thread in brown paper to keep it clean and white for shipping. (Courtesy of University of Louisville Photographic Archives.)

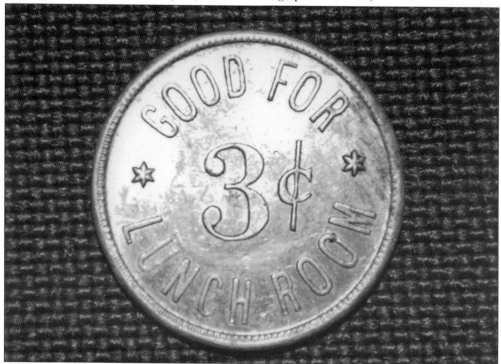

This is the front view of the coin that could be used to purchase an employee lunch at the Louisville Cotton Mill in the 1930s. (Courtesy of John Booker.)

This is the back view of the coin for 3¢ lunch at the Louisville Cotton Mill. Employees could eat lunch in the tower's small fifth-floor lunchroom or at tables on the rooftop. (Courtesy of John Booker.)

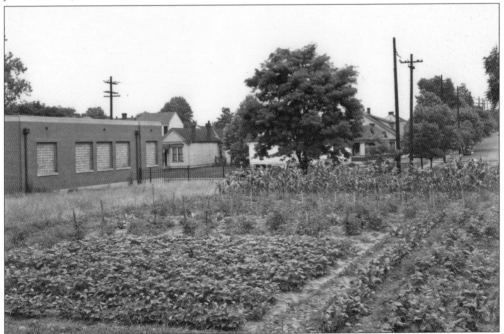

The mill workers planted a vegetable garden behind the building. The home at 1919 McHenry Street can be seen in the background. (Courtesy of University of Louisville Photographic Archives.)

Harry Geisburg, a World War II army captain and graduate of Clemson A&M came to Louisville to work for Louisville Textiles and eventually purchased the company. Harry would be remembered as the heart of the Louisville Textile Mill for his dedication to its successful operation. (Courtesy of the Geisburg family.)

During the 1930s and 1940s, a brand of upholstery and drapery fabric called "Fincastle" was manufactured here and sold worldwide. This beautiful bas-relief above the front on the mill's business office building at 1320 McHenry Street shows all the implements of the textile industry. (Author's collection.)

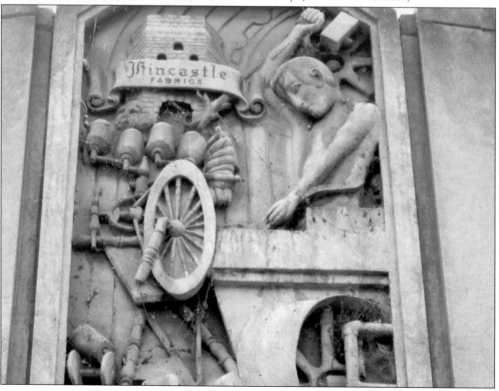

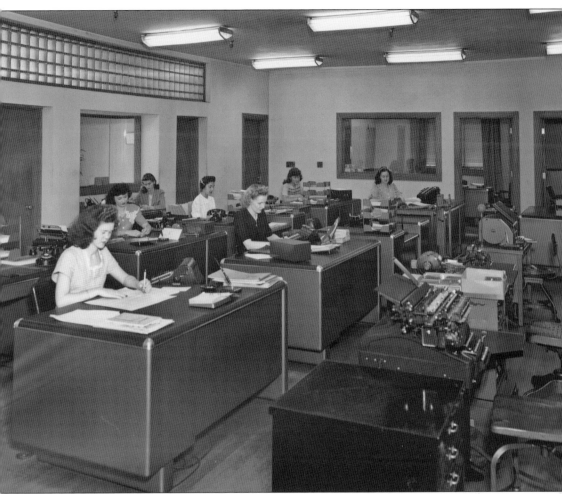

Ladies in the McHenry Street office work to fill orders for Fincastle fabric. Booker Price Wholesale Furniture Corporation would take over the facility in 1971. (Courtesy of University of Louisville Photographic Archives.)

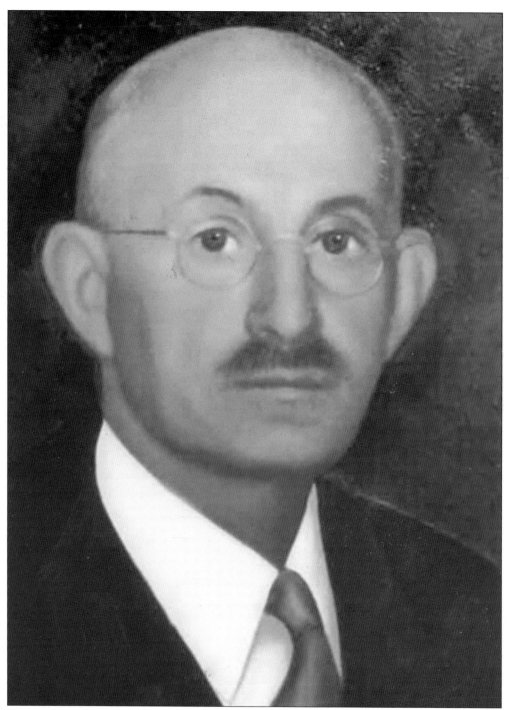

Herman Meyer immigrated to the United States in 1882 from Germany. He formed a partnership with Gustav S. Rosenberg Undertaking Company, which was founded in 1888. The business partners had a close friendship, and Herman named his second son Emanuel Gustav in honor of Gustav Rosenberg. Upon Gustav's death in 1925, Herman purchased the remaining percentage of the company. (Courtesy of Sonny Meyer.)

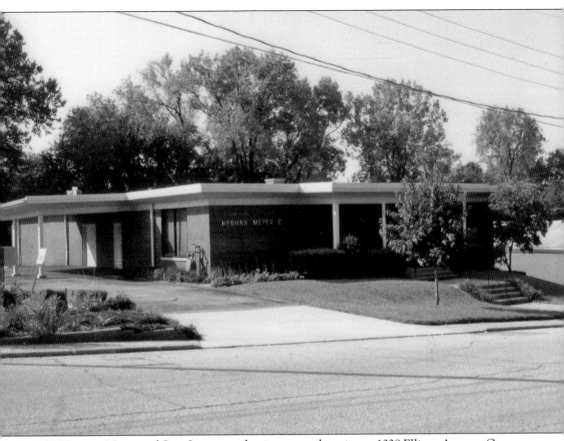

In 1957, Herman Meyer and Son, Inc., moved to its present location at 1338 Ellison Avenue. Over 50 years later, the third and fourth generations of the Meyer family continue to operate Herman Meyer and Son, Inc., from this Germantown location. (Courtesy of Sonny Meyer.)

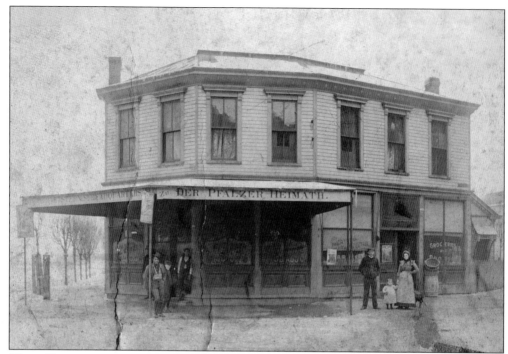

Christ Hartstern, a grocer, stands with his wife, Bertha, and daughter Christine in front of his store at Ash and Shelby Streets. The Hartsterns lived upstairs over the store. There is a snowy roof and lace panels in the upstairs windows. (Courtesy of Tammy Jones-Scrogham.)

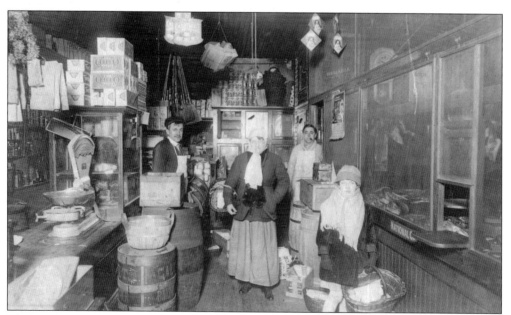

Christ Hartstern's store was located at Shelby and Ash Streets. Pictured in this photograph are Christ, ? Wenz, an unidentified child, and John Hartstern (rear). (Courtesy of Tammy Jones-Scrogham.)

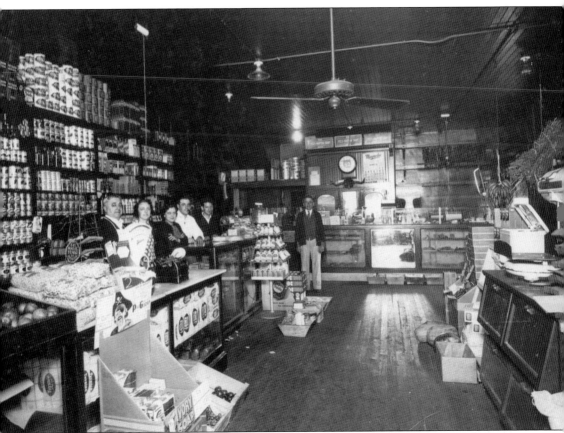

John Hartstern stocked Super Suds Soap Powder, Ivory Soap, and Taystee Bread for busy Germantown and Schnitzelburg ladies. He is pictured at his grocery store with family members as follows, from left to right: John Hartstern, Alma Hartstern Ruff, Dorothy Hartstern, Bernard Ruff, and two unidentified. (Courtesy of Tammy Jones-Scrogham.)

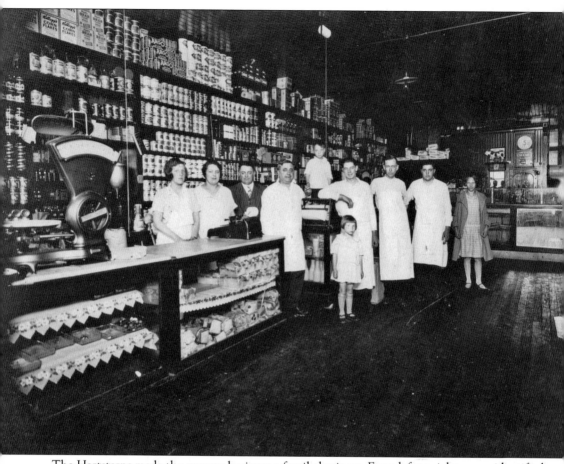

The Hartsterns made the grocery business a family business. From left to right are unidentified, Marie Hartstern, Jake Hartstern, John Hartstern, two unidentified children, two unidentified adults, son John L. Hartstern, and unidentified at Hartstern's store at Shelby and Mulberry Streets. (Courtesy of Tammy Jones-Scrogham.)

Fred Speier (second from left) arrived from Germany in 1935 at age 18. Fred was working in a hardware store when he married Dorothy Flexner, and they decided to open their own business. (Courtesy of Dorothy Speier and Kevin Katz.)

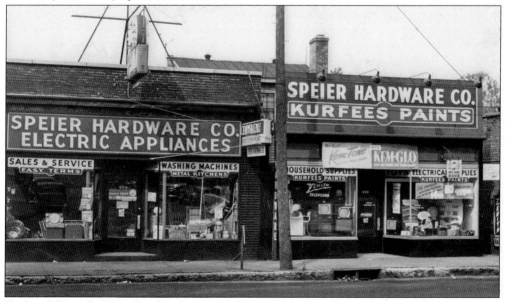

Fred and his wife, Dorothy, found an available storefront on the perimeter of Germantown at 990 Barret Avenue in 1941. They opened for business, and an expansive appliance showroom in the space soon followed. (Courtesy of Dorothy Speier and Kevin Katz.)

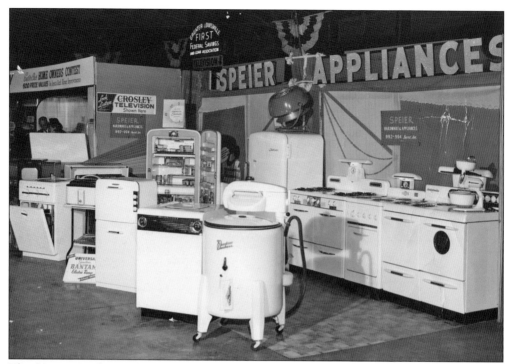

The Speier's Appliance showroom in 1948 had memorable brands on display, such as black and white Crosley televisions, Kaiser dishwashers, the best selling Crosley Shelvador 5-way refrigerator, Bantam electric ranges, and Grand gas ranges. (Courtesy of Dorothy Speier and Kevin Katz.)

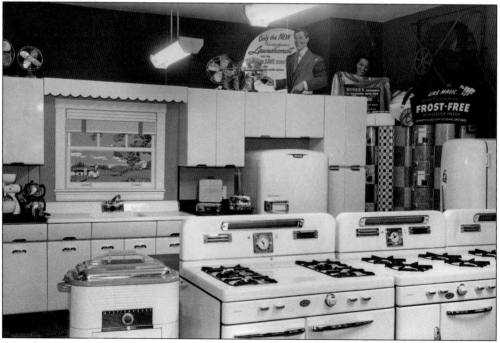

Many homes in Germantown and Schnitzelburg were remodeled with the Capitol all-steel kitchen cabinets, sold in three easy-to-install sections. (Courtesy of Dorothy Speier and Kevin Katz.)

James "Flabby" Devine, along with his wife, Marie, owned and operated the Schnitzelburg bar and restaurant Flabby's at 1101 Lydia Street. Together they ran the business from 1951 until Flabby retired in 1971. Built in 1890, the location of the restaurant was formerly known as Heinz's Grocery. In 1971, he sold the business to his son James Joseph and James's wife, Marcella. Like Flabby and Marie, James and Marcella would live upstairs over the restaurant. (Courtesy of Sadie Hartlege.)

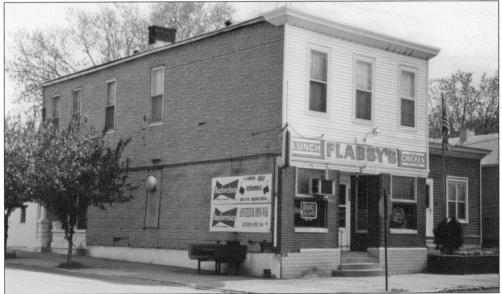

Although they had an excellent lunch business, the tavern became known for Marie's famous fried chicken sold on Friday and Saturday nights. The word spread, and people came from all areas of Louisville for the fried chicken dinner. A long, winding line would form down Lydia Street with waiting customers. During this time, there was no kitchen on the first floor, so Marie would fry chicken upstairs in her own kitchen and send it downstairs by dumbwaiter. (Courtesy of Carroll Ray Obst.)

Flabby (left) is pictured here with bartender Charlie Pope. (Courtesy of Sadie Hartlege.)

Flabby's was always a genial atmosphere for cold beer and discussion of local news, politics, and sports. Flabby, Arlis Rowe, and Henry Morgan (second from right) enjoy beers and discussion with neighborhood regulars. (Courtesy of Sadie Hartlege.)

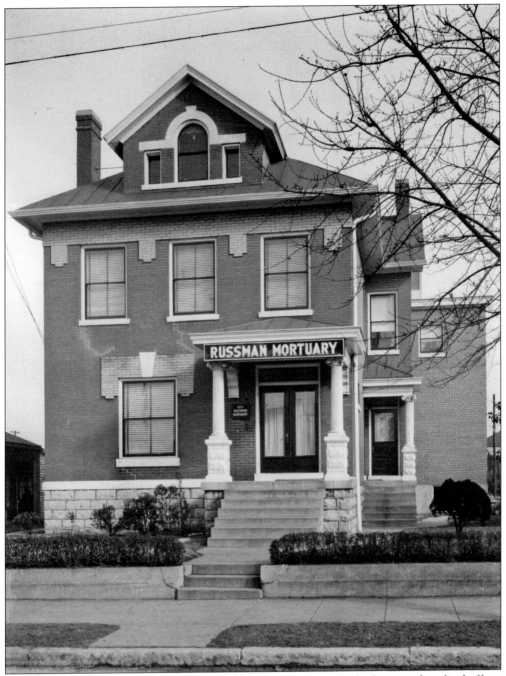

The Russman Mortuary was located at 1041 Goss Avenue, formerly the home and medical offices of Dr. Charles G. Russman. His son Godfrey Freihoefer "Doc" Russman purchased the family home in 1938 and opened the Russman Mortuary. (Courtesy of the University of Louisville Photographic Archives.)

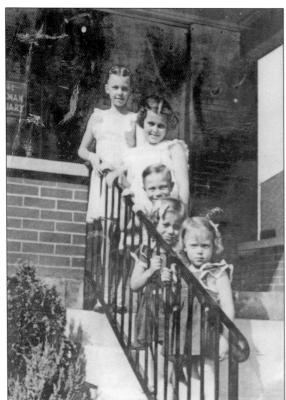

The Russman children, from the top, are Barbara, Libby, Godfrey, Carol, and Sharon. They are on the front steps of the mortuary in 1940. The children grew up on the spacious second floor over the funeral home and recall playing on these steps and the adjoining lot. (Courtesy of the Russman family.)

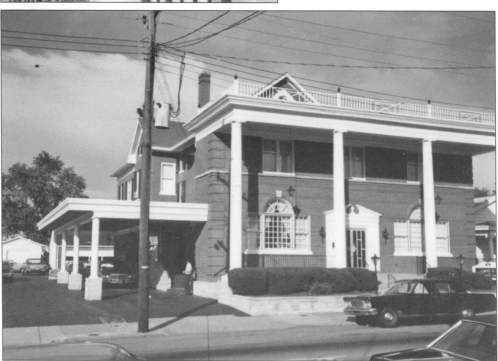

This is Russman's in the 1970s, much as it looks today. (Courtesy of the Russman family.)

Russman's continued to grow and expand over the next several decades, and changes were made to the original facade. (Courtesy of the Russman family.)

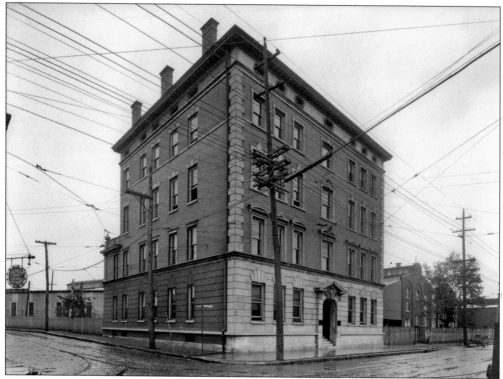

This is the Kentucky Refining Company building located at 1301 South Shelby Street. The cottonseed oil processing company was the second largest producer of cottonseed oil in the world in the late 19th and early 20th centuries. Van Camp Foods and Durkee Foods both owned the building at one point. In 1936, Glidden Company purchased the building. (Courtesy of the University of Louisville Photographic Archives.)

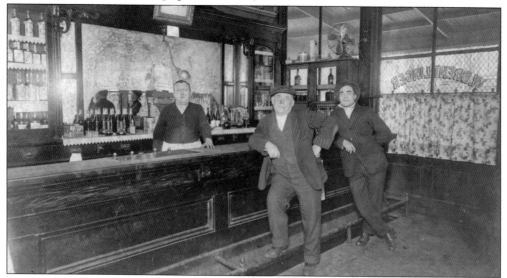

Wallace A. Brentlinger's Bar was located on Shelby Street and may have been part of the Hartstern grocery building. Pictured from left to right are bartender Jacob Hartstern, Wallace Brentlinger, and ? Gollar. (Courtesy of Tammy Jones-Scrogham.)

Two

COMMUNITY

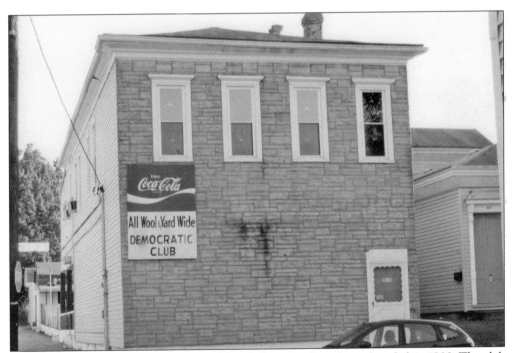

All Wool and a Yard Wide Democrat Club is believed to have been founded in 1900. The club was formed by woolen mill workers and named for the "all wool" and "yard wide" woolen goods produced at the nearby mill. All Wool is one of the few democrat clubs in Louisville that owns its building. (Author's collection.)

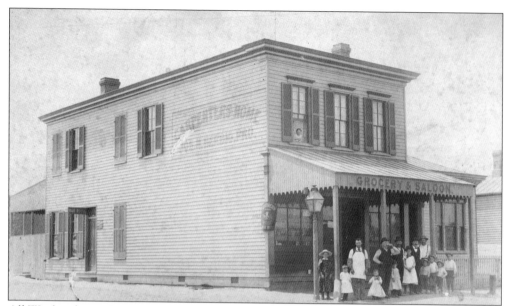

All Wool and a Yard Wide Democrat Club is located at 1328 Hickory Street, a building that was originally the location of Herbig's Grocery. (Courtesy of Anna Dale Ernst.)

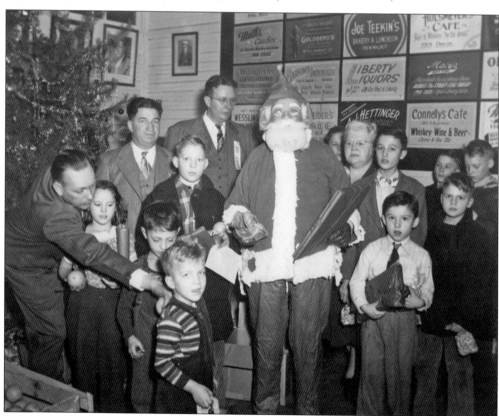

Democratic club president Ed Hulsman, pictured here at age 12, stands to the right of Santa at a club Christmas party. (Courtesy of All Wool and a Yard Wide Democrat Club.)

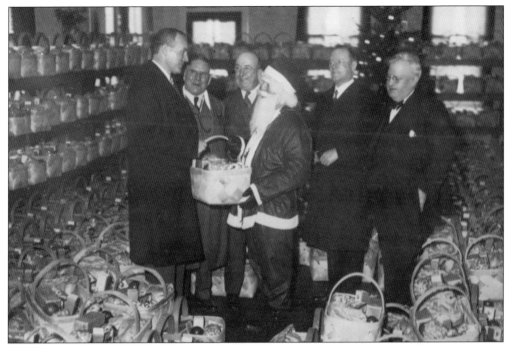

On Christmas Eve 1934, from left to right, Mayor Neville Miller, Judge J. B. Brachey, Maj. William Schmidt, Clarence O'Hern, M. J. Brennen, and J. E. Piazza prepare to deliver baskets to the needy. (Courtesy of All Wool and a Yard Wide Democrat Club.)

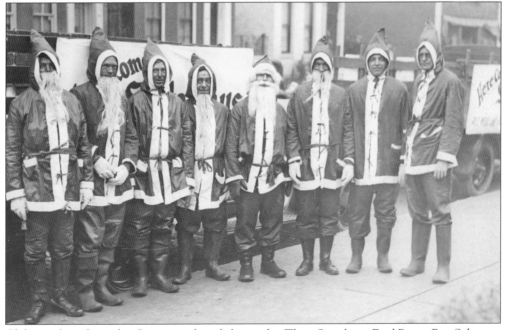

Club members dressed as Santa are, from left to right, Theo Osterberg, Fred Paper, Ray Scherzer, E. Riplinger, Clarence O'Hern, William Schmidt, Al Kirchner, and Oscar Montgomery. They are standing in front of a truck and trailer loaded with Christmas baskets. (Courtesy of All Wool and a Yard Wide Democrat Club.)

Club members, pictured from left to right, are John Stengel, Bart Zoepfel, Irish Crawley, Carl Russman, and Louis Glass. (Courtesy of All Wool and a Yard Wide Democrat Club.)

All Wool Club members pictured in this photograph are, from left to right, (seated) Mary Hulsman, Lawrence Osting, and Frances Stengel; (standing) Frank Hulsman and Andy Weigel. (Courtesy of All Wool and a Yard Wide Democrat Club.)

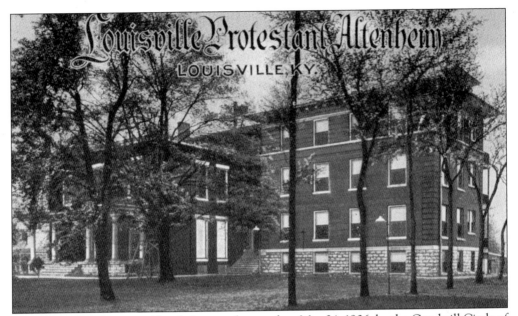

The Louisville Protestant Altenheim was chartered on May 24, 1906, by the Goodwill Circle of St. John's Evangelical Church. The former home of the Stewart family at 1622 Barret Avenue, St. John's purchased the property to establish a retirement home for the elderly. Over time, a two-story wing and a chapel were added. (Courtesy of the Altenheim.)

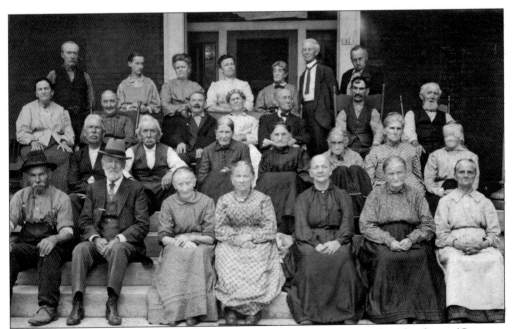

This photograph is believed to be of the first group of residents to live at the Altenheim. (Courtesy of the Altenheim.)

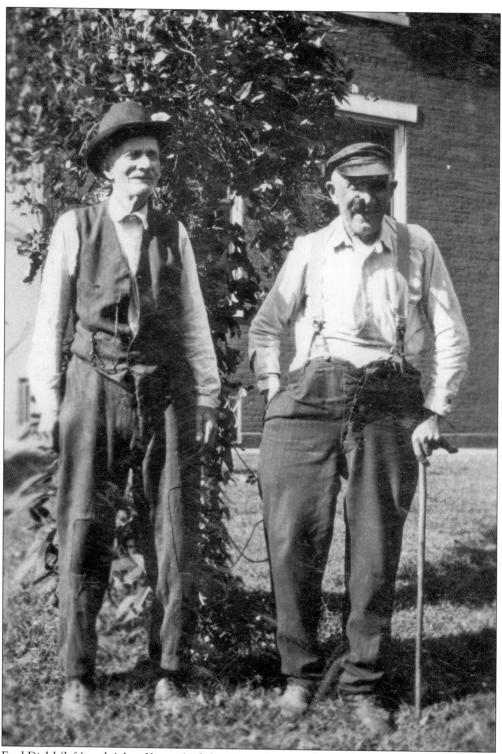

Fred Diehl (left) and Adam Young (right) enjoy and pipe and a stroll on the grounds. (Courtesy of the Altenheim.)

Opening in 1926 at 982 Eastern Parkway, Kosair Crippled Children's Hospital was this region's first free hospital for crippled children. The hospital provided orthopedic and polio treatment and care to all children. Architects Joseph and Joseph designed the two-story Tudor-style building. (Courtesy of the University of Louisville Photographic Archives.)

Dr. W. Owen Barnett was the first orthopedic specialist in Louisville and one of the driving forces behind the founding of Kosair Crippled Children's Hospital on Eastern Parkway. (Courtesy of the University of Louisville Photographic Archives.)

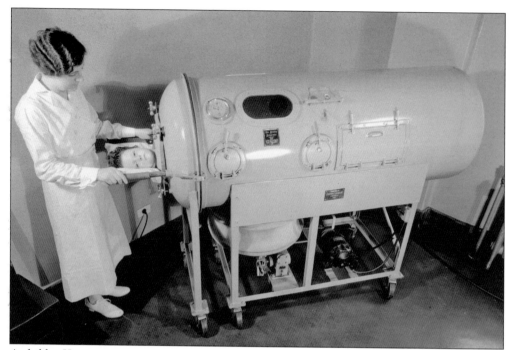

A child at Kosair receives treatment in the Drinker respirator, developed by Phillip Drinker. The respirator was used to treat children stricken with polio. Polio caused paralysis of the muscles, including those in the chest. (Courtesy of the University of Louisville Photographic Archives.)

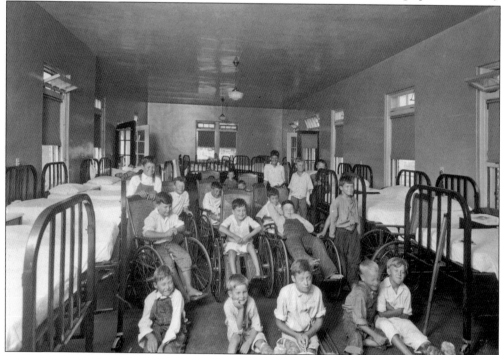

Children pose for a photograph in the "little boys ward" at the hospital in 1926. (Courtesy of the University of Louisville Photographic Archives.)

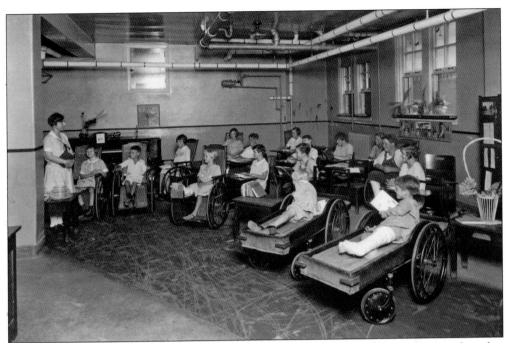

Children at Kosair were often at the hospital for long periods of time, and classes were conducted to keep children current in their studies. In this 1927 photograph, children attend class in wheelchairs or wheeled wagons. (Courtesy of the University of Louisville Photographic Archives.)

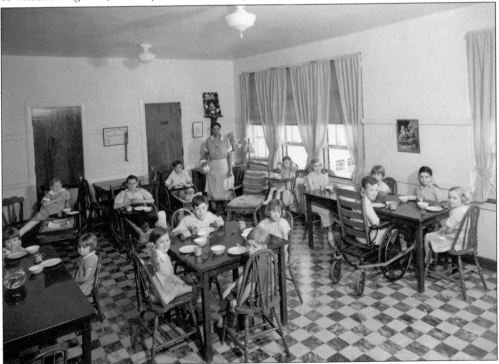

The children are pictured in the dining room in this 1937 photograph. (Courtesy of the University of Louisville Photographic Archives.)

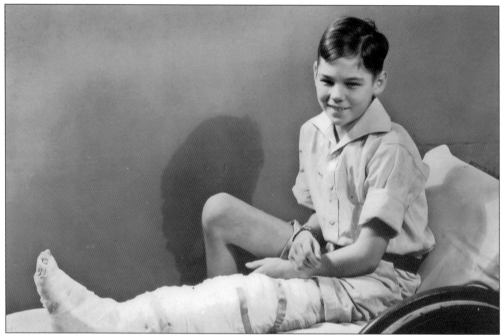

One of the best-known "Kosair Kids," Dr. James Hurt, pictured here at age 11, was diagnosed with a bone infection and brought to Kosair for treatment. His stay at Kosair inspired him to become an orthopedic surgeon, and he practiced for many years thereafter at the facility. (Courtesy of Kosair Charities.)

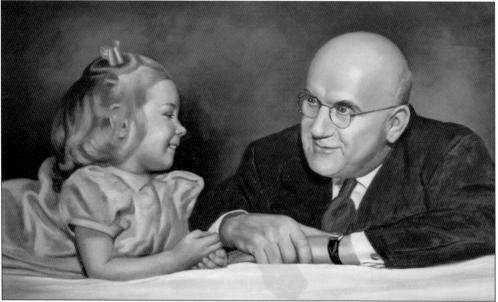

Kosair patient Judy Woods and Kosair president Bruce Hoblitzell are pictured in this beautiful painting. Known as "Mr. Hobby," Hoblitzell was president of the Kosair Crippled Children's Hospital's Board of Governors for three decades as well as chairman of the annual fund-raising picnic. Hoblitzell, dedicated to the care and welfare of the children at the hospital, was also Louisville's mayor from 1957 to 1961. (Courtesy of Kosair Charities.)

Due to the severity of their medical conditions, tiny patients often spent holidays at the hospital, away from their families. (Courtesy of Kosair Charities.)

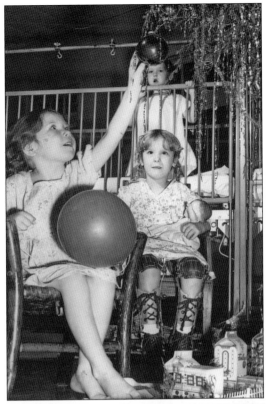

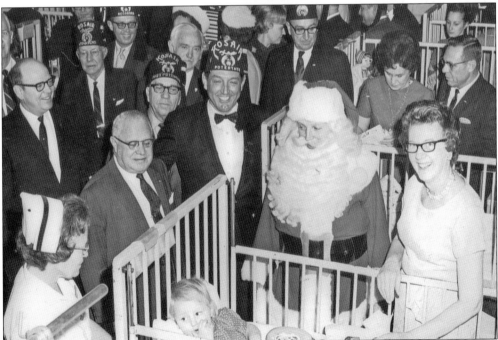

Santa and the Kosair Shriners visit the hospital on Christmas Eve to spread cheer among the children. (Courtesy of Kosair Charities.)

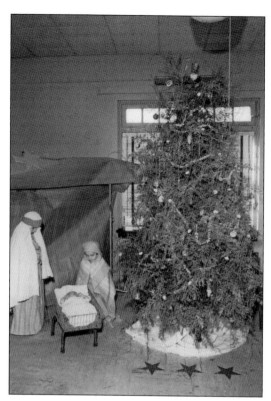

Three Kosair children participate in a living nativity at Christmas time. A small crutch can be seen just at the bottom hem of "Joseph's" robe. (Courtesy of Kosair Charities.)

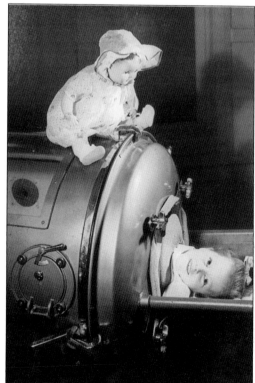

A doll is placed atop the respirator for the gazing enjoyment of a young little patient. (Courtesy of Kosair Charities.)

Famed zoologist Dian Fossey was an occupational therapist at Kosair following her graduation from San Jose State College in 1954. (Courtesy of Kosair Charities.)

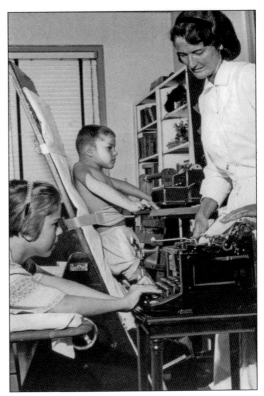

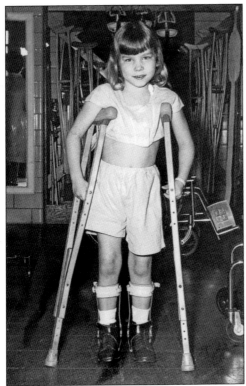

A little girl is fitted with crutches and braces. The brace shop fitted patients big and small. (Courtesy of Kosair Charities.)

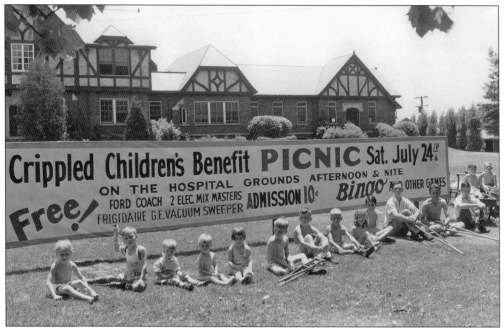

The annual Kosair picnic is a fond memory for Germantown and Schnitzelburg residents. The inaugural picnic took place in 1924, and the last one was held in 1959. The picnic took place in the summertime over a long weekend. Attendees enjoyed dozens of cake, grocery, and beer booths, along with live entertainment and amusement rides. Cars would be parked on Burnett Avenue, Lydia Street, Reasor Avenue, Ash Street, and Texas Avenue for blocks. The children of Kosair anticipated this picnic as much as the community. (Courtesy of Kosair Charities.)

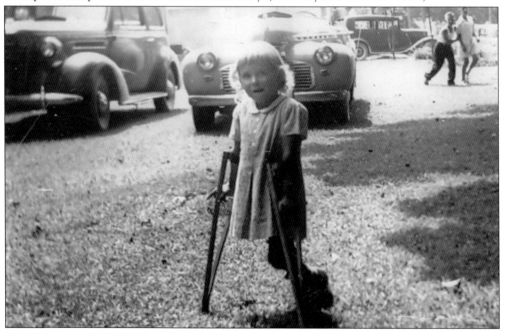

A small Kosair patient at the picnic makes her way across the grounds. (Courtesy of Kosair Charities.)

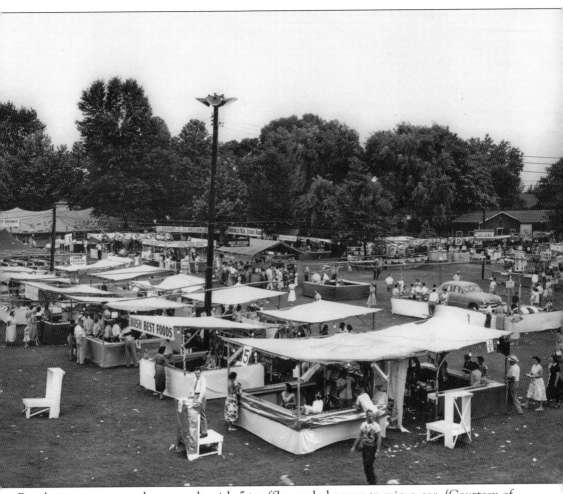

Booths are set up on the grounds with 5¢ raffles and chances to win a car. (Courtesy of Kosair Charities.)

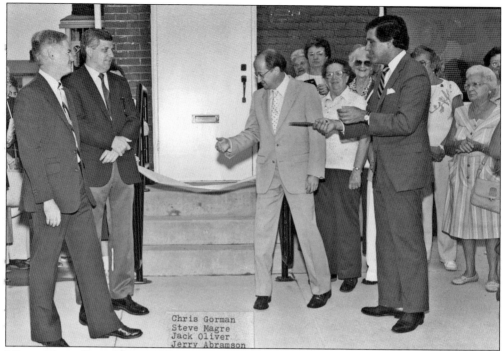

Chris Gorman
Steve Magre
Jack Oliver
Jerry Abramson

Missouri-born Steve Magre is the former president of the Louisville Board of Alderman and a longtime Germantown resident. Steve and his wife, Judy, wed in 1971 and moved to their first home in Schnitzelburg on Lydia Street, then a house on Ash Street, before buying the home in Germantown, where they have lived for three decades. In this photograph, Mayor Jerry Abramson cuts the ribbon for the opening of the Germantown/Paristown Neighborhood Center. (Courtesy of Steve Magre.)

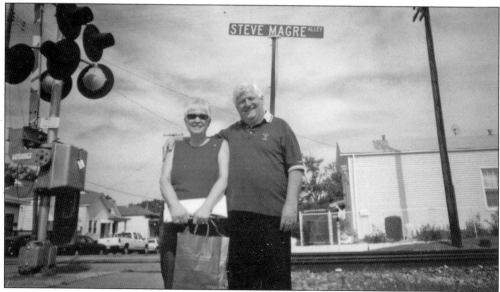

Steve Magre established the quiet zone in Schnitzelburg and Germantown, preventing train-whistle blasts at night while traveling through his ward. In 2007, Steve Magre Alley was dedicated in his honor. (Courtesy of Steve Magre.)

The World Dainty Contest was introduced to Schnitzelburg by George Hauck. Dainty is derived from a street gamed played by German children living in Louisville in the 1860s. George and childhood friend Charlie Vettiner decided to hold the first dainty contest at Hauck's Handy Store in 1971. George put an ad in the *Mid-City Star* newspaper announcing the contest. It has been an annual tradition on the last Monday in July since that time. The first dainty contest was won by Pete Goeing. In this photograph, George Hauck (left) and Charlie Vettiner (right) pose with the dainty trophy. (Courtesy of George Hauck and family.)

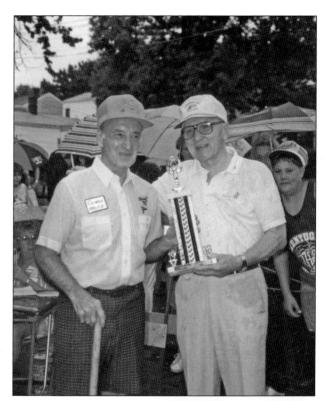

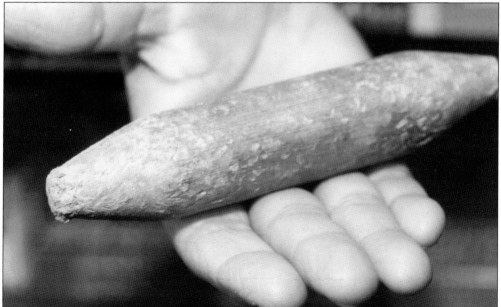

The dainty is a wooden stick carved at both ends. Players strike one end of the dainty and cause it to flip into the air and then try to "bat" the dainty a distance with a broomstick. The winner is the person who can strike the dainty the furthest distance. It is believed that the word "dainty" derived from the "dainty man" or ice cream man, who would sell a frozen confection shaped like the dainty. (Photograph by Marife Bautista, used with permission.)

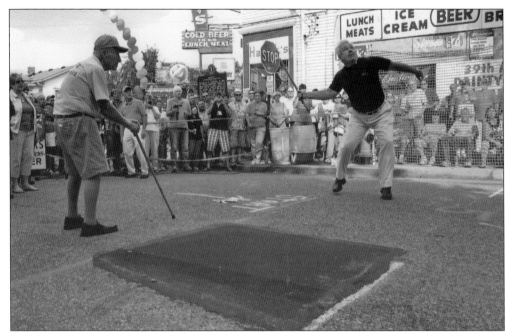

George Hauck encourages Germantown and Schnitzelburg's councilman Jim King as he takes a turn at hitting the dainty. (Photograph by Jesse Inman-Hendrix, used with permission.)

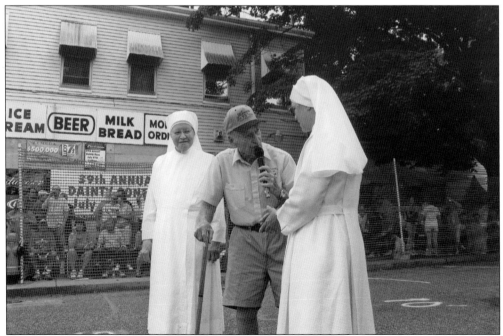

George Hauck talks with Sister Bernard and Mother Provincial Maria Christine Joseph, both of Little Sisters of the Poor. Donations are traditionally made to Little Sisters of the Poor during the dainty contest. (Photograph by Jesse Inman-Hendrix, used with permission.)

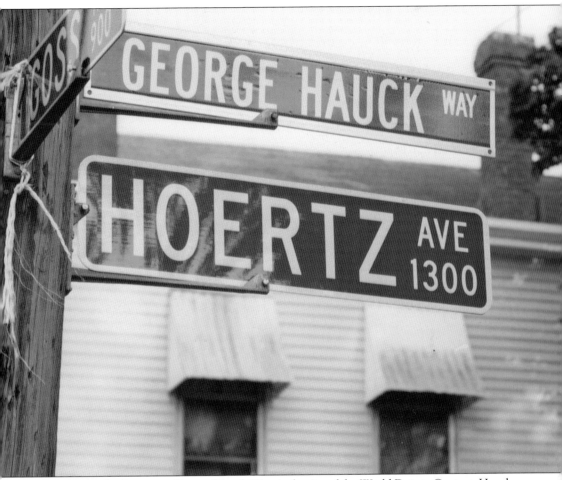

Hoertz Avenue, also known as George Hauck Way, is the site of the World Dainty Contest. Hauck received this honorary street sign in 2002 for his contributions to Germantown and Schnitzelburg. (Photograph by Marife Bautista, used with permission.)

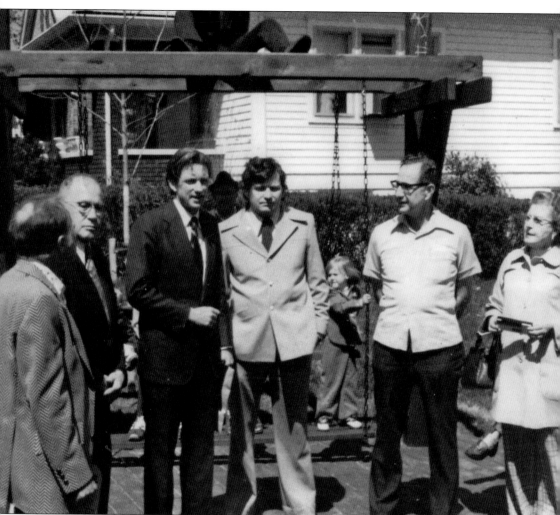

This is at the dedication of Gnadinger Park in Germantown on April 7, 1977. The parcel at the corner of Reutlinger and Ellison Avenues was gifted to the community by the Gnadinger family in memory of Frank A. and Mary Catherine Gnadinger. Pictured from left to right are Carl Gnadinger, Bernie Gnadinger, Louisville mayor Harvey Sloan, Steve Magre, Norb Gnadinger, Mary Catherine Gnadinger Wantland, and Creighton Mershon. (Courtesy of David Gnadinger and the Gnadinger family.)

Three

RELIGIOUS LIFE

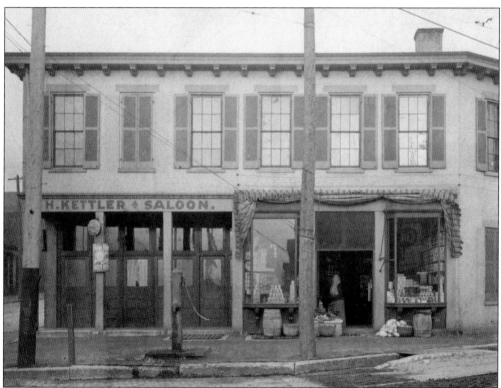

The original site of Christ Evangelical Church was very close to the location of the present church. The church was organized on May 15, 1879, by the Reverend John Brodman with the following charter members: Peter Heyer, John Seuboldt Sr., John Kreiser, Henry Miller, Louis Weber, and Samuel Yent. It was located upstairs over Loeder's Hall, at the corner of Broadway and Barret Avenue. Attendance increased quickly, and more space for meeting was gained by the removal of an inner wall, making two small rooms into one large one. (Courtesy of Christ Evangelical UCC.)

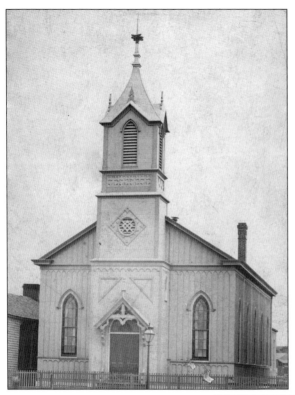

The second site of the church was built on Garden Street in 1880 on a small lot adjacent to Struck's Planing Mill. The cornerstone for this church was laid on January 11, 1880, and the church was completed four months later. The Ladies Aid purchased bells for the belfry in 1890. Reverend Brodman led the congregation until 1883. Rev. Albert Schory of Vincennes, Indiana, became the new pastor. He served until 1896 and then was succeeded by Rev. H. F. Frigge. (Courtesy of Christ Evangelical UCC.)

Reverend Frigge brought changes to the congregation, including services in English, and a new location at Breckinridge Street and Barret Avenue. The cornerstone of the new church was laid on June 9, 1901, and the church was dedicated on December 15, 1901. A year later, the parsonage was erected adjacent to the church. (Courtesy of Christ Evangelical UCC.)

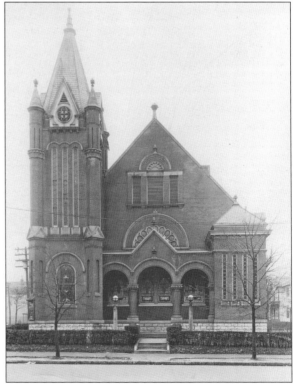

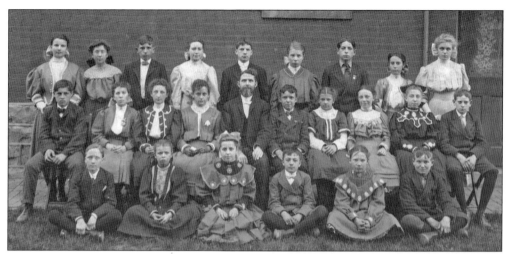

The 1906 Confirmation class is pictured here with Rev. H. F. Frigge. (Courtesy of Christ Evangelical UCC.)

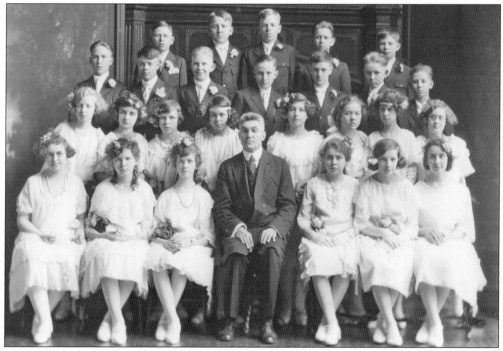

The Confirmation class of 1923 is pictured here with Rev. W. L. Krueger. Reverend Krueger was perhaps the most beloved of all of the early pastors to serve Christ Evangelical Church. He served the congregation from 1918 to 1948. Pictured with Reverend Krueger are, from left to right, (first row) Catherine J. Marmillot, Adele E. Marker, Ethel A. Franck, Reverend Krueger, Ruth K. Hammerle, Lillian L. Loeffler, and Anna A. Pusey; (second row) Willetta Squier, Ruth Mernoff, Margaret A. Hart, Henrietta B. Hodapp, Martha W. Wuest, Louise S. Miller, Ruth P. Brandt, and Helen L. Kasper; (third row) George W. F. Schmidt, Perry W. L. Finck, Samuel Meyer, Frank C. Heinz, Stanley J. C. Weigel, Roy E. Gaum, and Martin Messmer; (fourth row) Walter L. Heibert, Henry G. Schneller, Clifford W. Torsch, Oscar H. Gunn, and Herbert H. L. Volk. (Courtesy of Christ Evangelical UCC.)

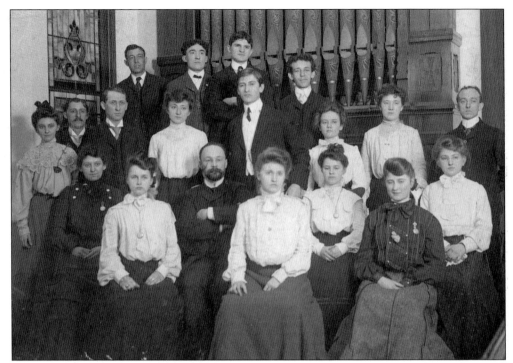

The choir members are pictured here in front of the organ. Pictured from left to right are (first row) Louise Sutterlin, Anna Meyer, and Emma Klemm; (second row) Mayme Ulrich, Professor Witte, Hannah Sutterlin, and Lena Kraft; (third row) Lulie Meyer, George Beck, William Schandelmeier, Anna Kraft, Edward Klemm, Mary Lochmeier, Augusta Franck, and John Weibert; (fourth row) Albert Seibert, George Martin, William Strohm, and William Schneider. (Courtesy of Christ Evangelical UCC.)

The children are performing a pageant for the congregation in this mid-1920s photograph. (Courtesy of Christ Evangelical UCC.)

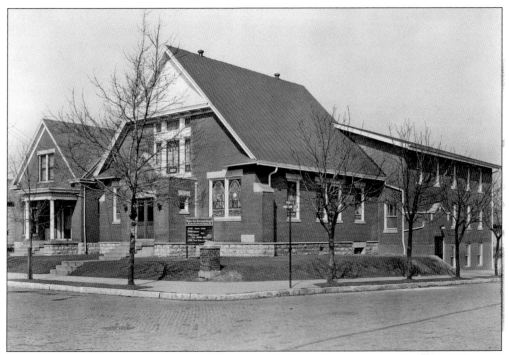

The German Reformed Zion Church was organized on December 2, 1849. This was the first Reformed church in Kentucky. The designation "German" was dropped from the name in 1867, but services were still conducted in German until 1900. A mission Sunday school began in 1906 on the northeast corner of Lydia and Hickory Streets. In 1907, the Milton Avenue Reformed Church was built at Milton and Hoertz Streets. The denomination name was changed in 1934 to an Evangelical and Reformed Church. (Courtesy of the University of Louisville Photograph Archives.)

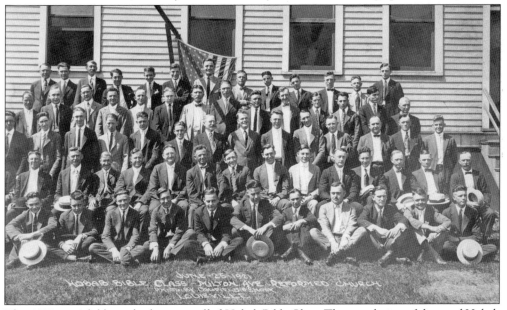

This 1921 men's bible study class was called Hobab Bible Class. The translation of the word Hobab is "beloved." (Courtesy of Zion Evangelical and Reformed Church.)

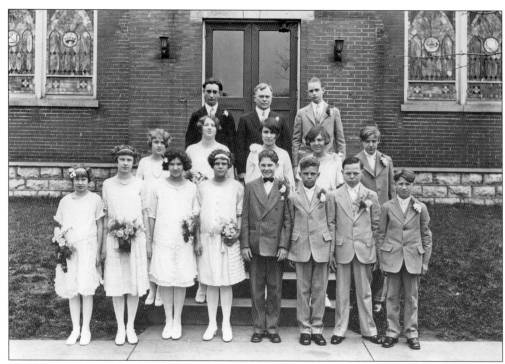

The 1925 confirmation class is pictured with Pastor Lienkemper. (Courtesy of Zion Evangelical and Reformed Church.)

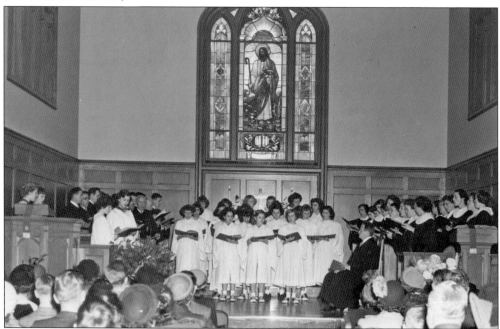

In 1946, the congregations of Zion, Milton Avenue, and Faith Mission merged to form Zion Evangelical and Reformed Church. Plans were approved for building a larger church. The organ and the Good Shepherd window (pictured here) were removed for installation in the new building. (Courtesy of Zion Evangelical and Reformed Church.)

Ground was broken for the present location of the Zion Evangelical and Reformed Church at Burnett and Minoma Avenues on January 15, 1950, and the cornerstone was laid on March 19, 1950. (Courtesy of Zion Evangelical and Reformed Church.)

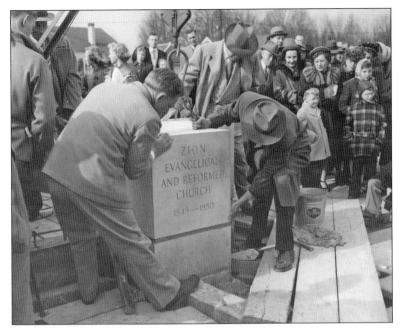

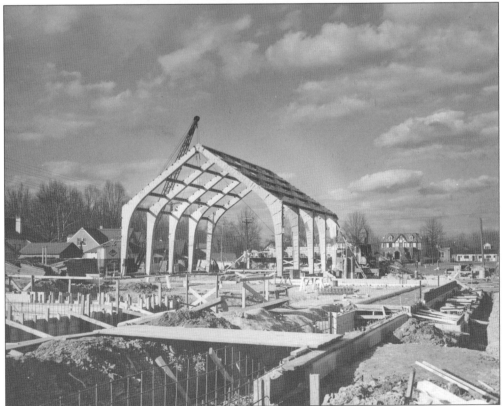

Framing of the chapel takes shape at the new location at Burnett and Minoma Avenues. Kosair Children's Hospital is seen in the background. (Courtesy of Zion Evangelical and Reformed Church.)

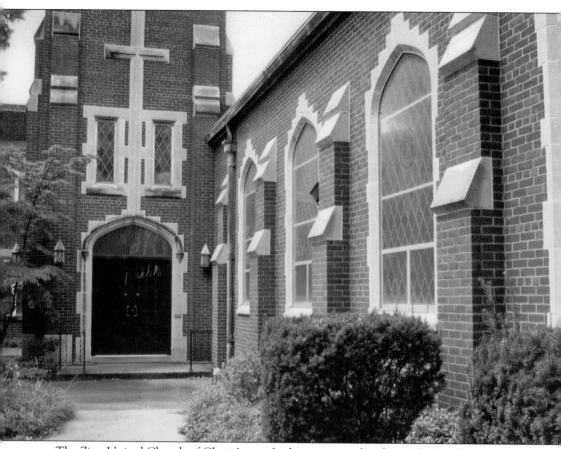

The Zion United Church of Christ's new facility was completed in 1951. (Author's collection.)

On December 12, 1905, Rev. James J. Asset was appointed pastor of the Church of St. Elizabeth of Hungary. Architect D. X. Murphy was engaged, and the cornerstone was laid in March 1906. (Courtesy of the Archdiocese of Louisville.)

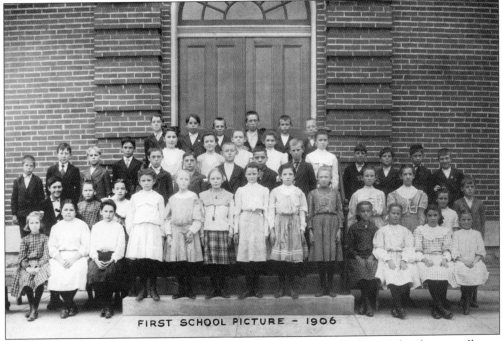

FIRST SCHOOL PICTURE – 1906

The building was dedicated on September 2, 1906. St. Elizabeth's school opened with an enrollment of 200 taught by Sacred Heart Ursuline nuns. Pictured here in 1906 is the first class of St. Elizabeth's. (Courtesy of the Archdiocese of Louisville.)

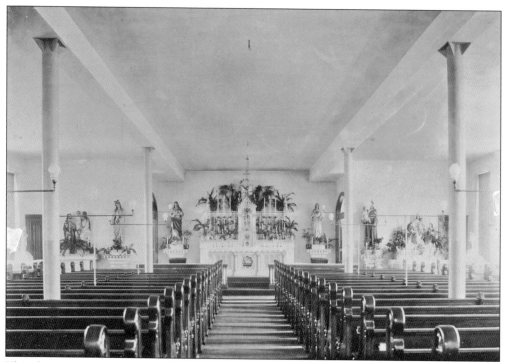

This photograph shows how the interior of the chapel looked in 1906. (Courtesy of the Archdiocese of Louisville.)

On February 9, 1927, Rev. John F. Knue was transferred to St. Elizabeth's from St. Columbia Church. Father Knue established the Catholic Students Mission Crusade at St. Elizabeth School. (Courtesy of the Archdiocese of Louisville.)

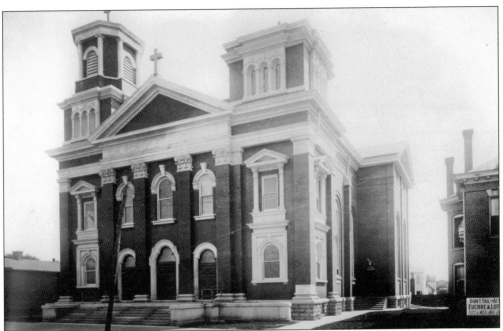

This early photograph shows the exterior view of St. Elizabeth's prior to the building of the new convent in 1951. (Courtesy of the Archdiocese of Louisville.)

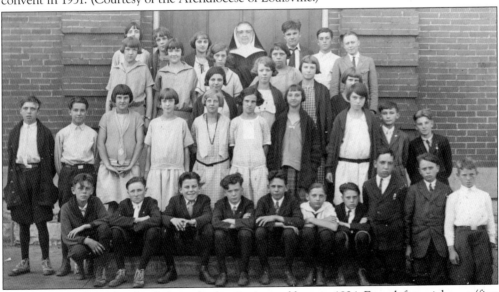

The St. Elizabeth's School eighth-grade class is pictured here in 1924. From left to right are (first row) George Bowles, Anthony Hellman, John Spoelker, Herman Rawert, Roman Schester, Edward Erb, Gerald Miller, Charles Stark, Emanuel Breitenstein, and Clement Schmidt; (second row) John Schneider, Edward Block, Marcella Habenstein, Catherine Voll, Henrietta Loeser, Elizabeth Brunes, Lucille Amos, Margaret Moser, Charles Nix, and Burchman Schmidt; (third row) Geneva Kiefer, Agnes Kiefer, Helen Knieburhler, Evelyn Mahoney, Lydia Schaaf, and Martha Weber; (fourth row) Geneva Schrecker, Clara Rudie, Thelma Smither, Beatrice Beckman, Sister M. Stanislaus, OSU, Gertrude Royer, Louis Reiel, Frank Steier, and Godfrey F. Russman. (Courtesy of the Archdiocese of Louisville.)

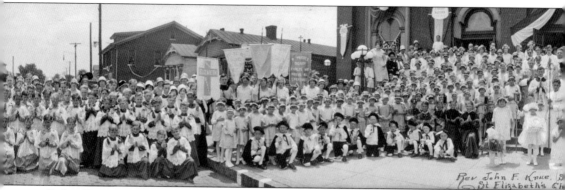

Father Knue, pictured here on the Silver Jubilee Friends Day in 1928, is widely recognized for being instrumental in not only the increase in enrollment at St. Elizabeth's to more than 1,000 youth, but also for the extensive athletic program developed within the school and parish, which

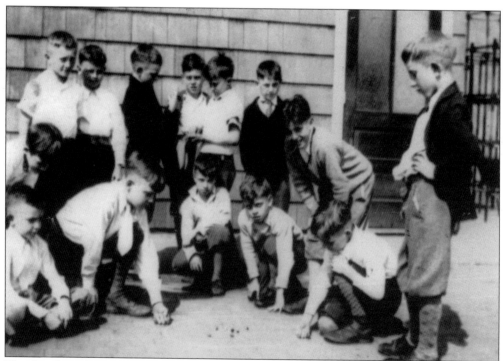

The fourth-grade St. Elizabeth's boys shoot marbles after school or during recess in this 1935 photograph. (Courtesy of the Archdiocese of Louisville.)

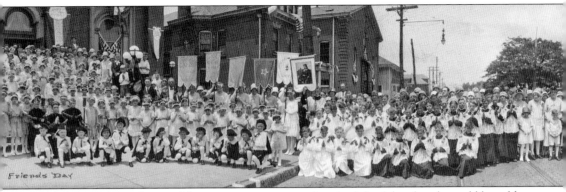

extended throughout the city. The two cottages pictured to the left of the church would be sold to neighboring baker Charles Heitzman in 1950 and moved behind his bakery. (Courtesy of the Archdiocese of Louisville.)

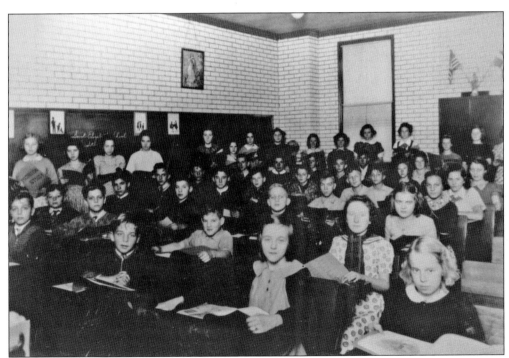

Increased enrollment at St. Elizabeth's made classrooms tight. Some classes, such as the one pictured here, were held in the second floor over the priest's garage in 1938. (Courtesy of the Archdiocese of Louisville.)

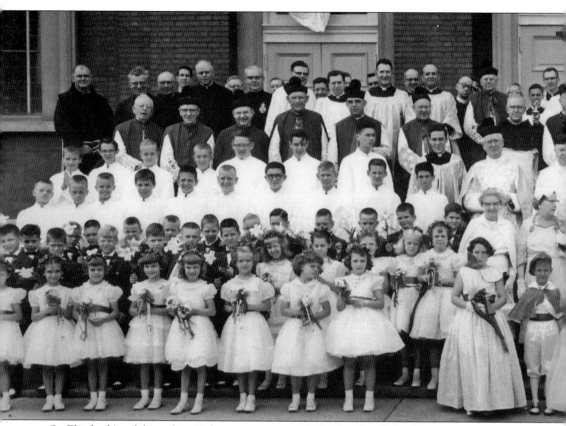

St. Elizabeth's celebrated its 40th anniversary in 1946. The church has been a strong presence in Schnitzelburg since its founding in 1906. Second- and third-generation German immigrants made up the congregation, and church members formed an impressive host of community organizations,

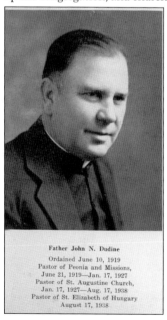

Father John N. Dudine
Ordained June 10, 1919
Pastor of Peonia and Missions,
June 21, 1919—Jan. 17, 1927
Pastor of St. Augustine Church,
Jan. 17, 1927—Aug. 17, 1938
Pastor of St. Elizabeth of Hungary
August 17, 1938

In 1938, Rev. Monsignor John D. Dudine was appointed to succeed Father Knue, who was transferred to Holy Trinity Church in St. Matthews. (Courtesy of the Archdiocese of Louisville.)

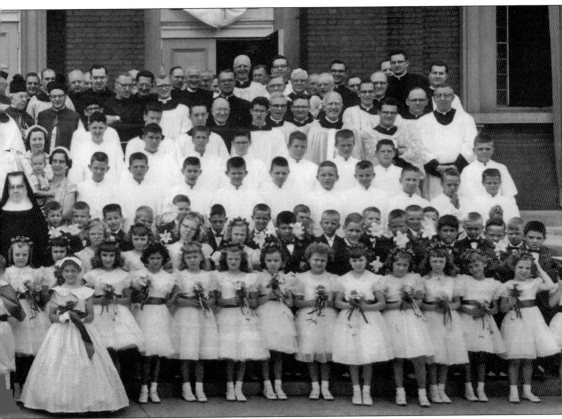

including but not limited to the Boy Scouts of America, the Kids of St. Elizabeth Club, chapters of the St. Vincent de Paul and St. Joseph's Orphan Societies, the PTA, and countless community outreach programs. (Courtesy of the Archdiocese of Louisville.)

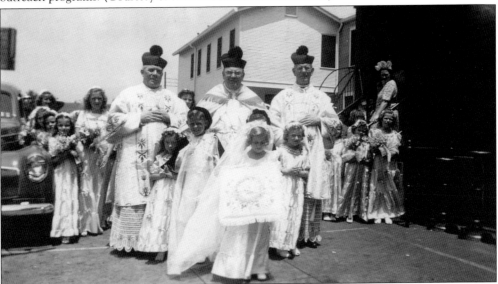

Like Father Assent, Father Ruff, and Father Knue, Monsignor Dudine also celebrated his silver jubilee at St. Elizabeth's. (Courtesy of the Archdiocese of Louisville.)

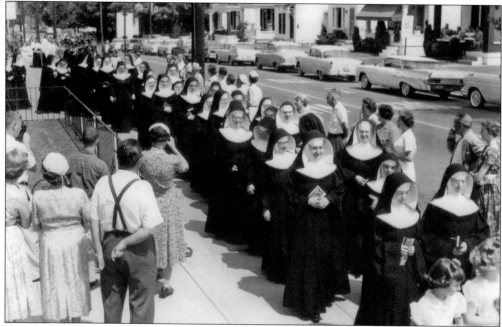

The long procession marches down Burnett Avenue into St. Elizabeth's on Monsignor Dudine's silver jubilee on June 11, 1944. (Courtesy of the Archdiocese of Louisville.)

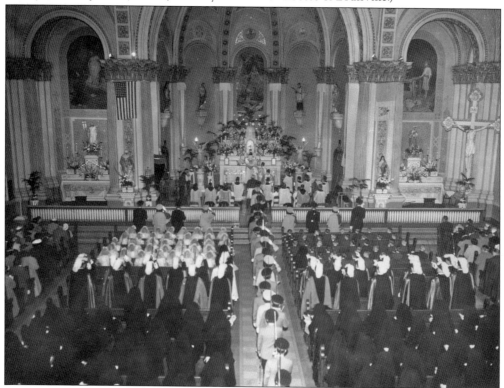

This photograph shows the chapel of St. Elizabeth's in 1959. (Courtesy of the Archdiocese of Louisville.)

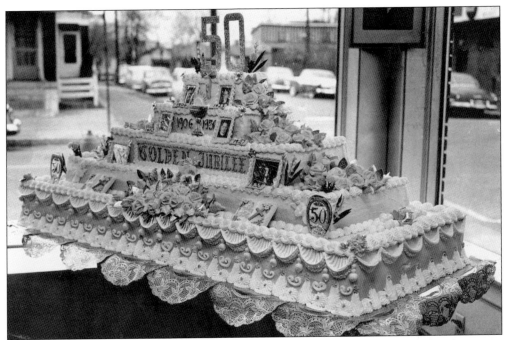

Charles Heitzman, known for his beautiful cake decorating, created this detailed and intricate cake to celebrate St. Elizabeth's golden anniversary. This photograph shows the cake on display at the bakery in 1956. (Courtesy of the Archdiocese of Louisville.)

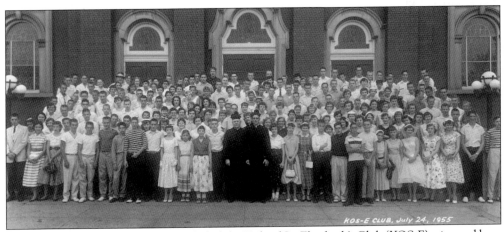

Youth programs at St. Elizabeth's included the Kids of St. Elizabeth's Club (KOS-E), pictured here in 1956. (Courtesy of the Archdiocese of Louisville.)

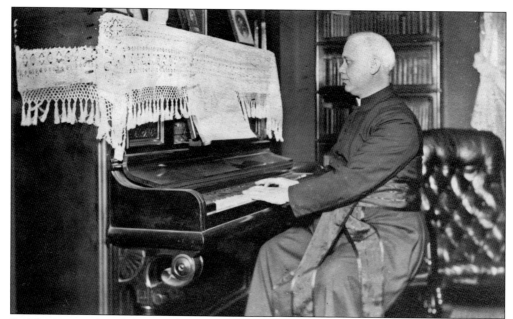

St. Thérèse was founded in 1906 as Holy Trinity Parish. Fr. John Peter Berresheim, an emigrant from Andernach, Germany, led the congregation. Construction of a school and church began, and the new building opened in 1907 with classrooms on the second floor and the church on the first floor. Father Berresheim is pictured here at a piano in the rectory. He made this photograph into a postcard to send Christmas wishes in December 1912. (Courtesy of the Archdiocese of Louisville.)

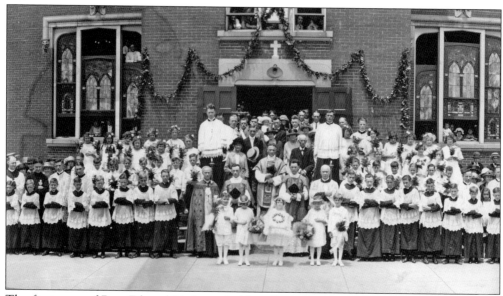

The first mass of Rev. Edward Link was held on June 17, 1923, at Holy Trinity. When the new church was built in 1927, this building would be converted to the school for St. Thérèse. The stained-glass windows in this photograph were replaced with clear glass. (Courtesy of the Archdiocese of Louisville.)

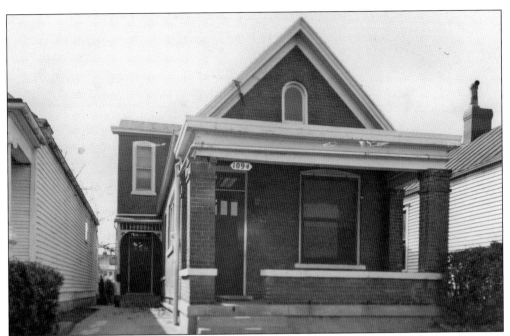

Two cottages on the southwest corner of Dupuy Street (now Schiller Avenue) and Kentucky Street were obtained shortly after the parish school opened. One was the residence for the Sisters, and the other was used for classes. Pictured here is the cottage at 1094 East Kentucky Street. (Courtesy of the Archdiocese of Louisville.)

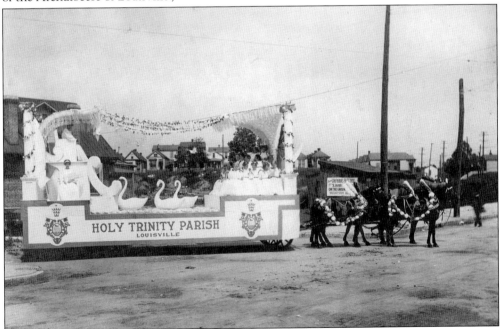

Holy Trinity Parish's float, symbolizing peace, is waiting for a parade to begin at the corner of Dupuy and Kentucky Streets in 1912. The parish participated in the celebration with the National Convention of the American Federation of Catholic Societies. The parade was estimated to be 8 miles long and consisted of 20,000 Catholics. (Courtesy of the Archdiocese of Louisville.)

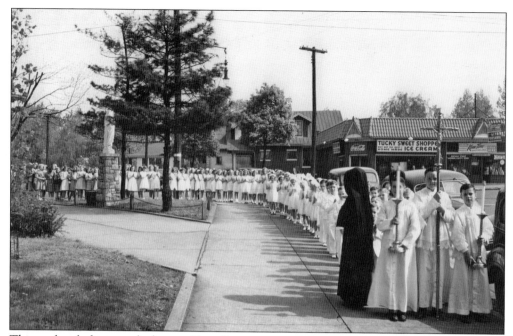

This undated photograph shows a First Communion procession into Holy Trinity Church on a clear, sunny morning. Tucky's Sweet Shoppe in the background is believed to be named for Kentucky Street. Next door to Tucky's is Kentucky Street Hardware and Variety Store. (Courtesy of the Archdiocese of Louisville.)

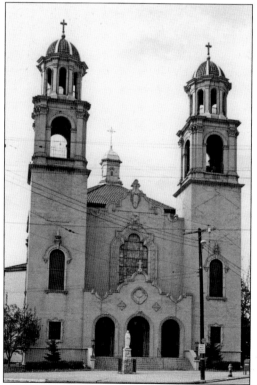

Construction of the new church began in 1927. Because there were two churches named Holy Trinity, then-pastor Fr. Andrew Zoeller requested that the new church be named in honor of the newly canonized Carmelite Sister Saint Thérèse of Lisieux, known as "The Little Flower." Pictured here is the nearly completed building in 1927. St. Thérèse Church is known for its unique Spanish baroque and revival architecture with a red tile roof designed by Fred T. Erhart. The well-recognized towers can be seen over the rooftops of houses from several directions. (Courtesy of the University of Louisville Photographic Archives.)

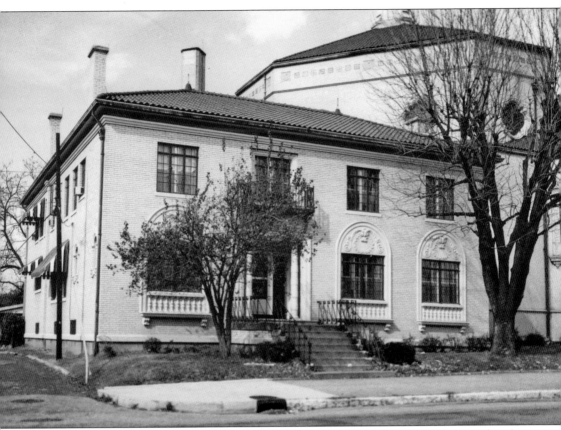

The priests moved into the new rectory on Schiller Avenue in December 1928. The new church was dedicated by Bishop John A. Floersh on June 30, 1929. Father Zoeller's inspiration for the design of the church was due to a recent trip to the holy land, where the architecture was a great influence on his vision. This style is also reflected in the rectory's exterior. (Courtesy of the Archdiocese of Louisville.)

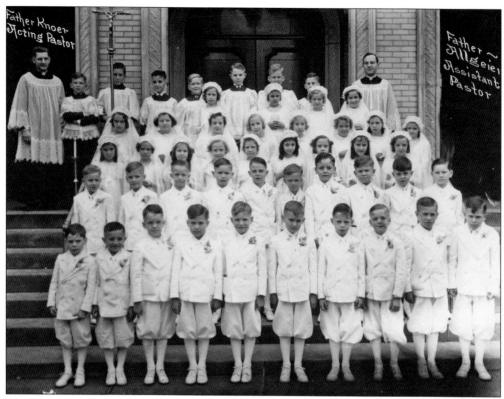

The First Communion class of 1941 is pictured here with Fr. Bernard Knoer and Fr. Joseph Allgeier. (Courtesy of the Archdiocese of Louisville.)

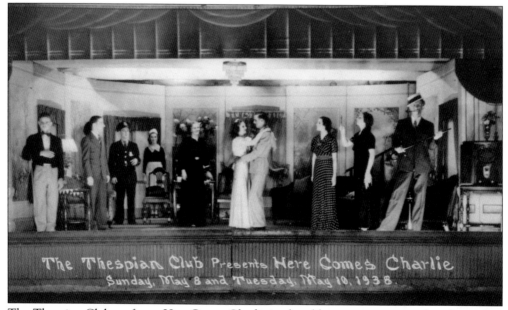

The Thespian Club performs *Here Comes Charlie* in the old gym, sometimes referred to as the "old wooden gym" or the "green gym," in 1938. The Thespian Club was formed between 1937 and 1938. (Courtesy of the Archdiocese of Louisville.)

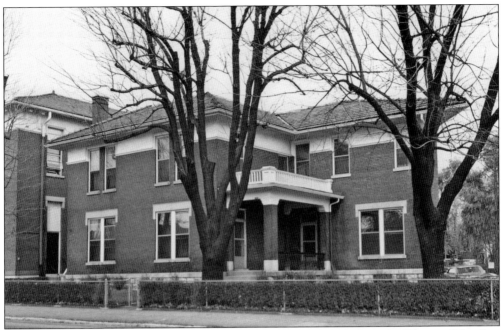

Instead of cottages, a new convent was built for the nuns who taught at St. Thérèse School to live in. (Courtesy of the Archdiocese of Louisville.)

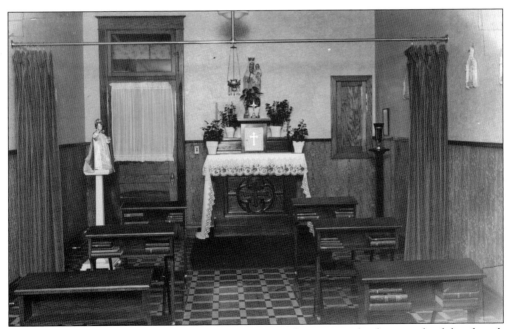

The nuns had their own chapel within the convent. This is an early photograph of the chapel. (Courtesy of the Archdiocese of Louisville.)

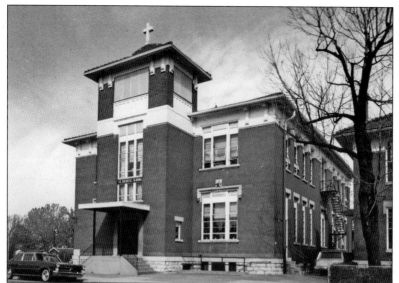

The original church was converted into St. Thérèse School. Next door to the church is the convent. (Courtesy of the Archdiocese of Louisville.)

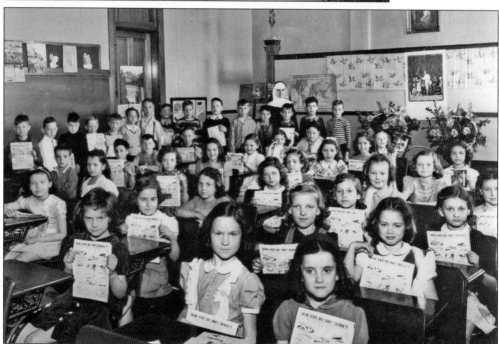

St. Thérèse third graders sit in neat orderly rows of desks in this 1945 photograph. The class included the following students, from left to right: (first row) Ellen Noland, Mary Ann Grass, Janice Nugent, and Margie Drane; (second row) Madeline Bryant, Janice Dewald, Barbara Zephel, Ann Waite, Norma Jean Krull, and Rosemary Leichefeld; (third row) Janie Mutler, Jean Huber, Janet Paulin, Mary Trot, Mary Lou Ormarod, Judy Flaherdy, Dorothy Kuebler, and Theresa Krider; (fourth row) Pat Krach, Mary Ann Mitchell, Janice Kenect, Barbara Schank, Alfreda Gravatte, Carol Kinnairde, and Joe Dugan; (fifth row) Doug Logsdon and Carl Heger; (standing) Tommy West, Jack Straub, Matt McDermott, Bobby Snyder, Tommy Slusher, unidentified, Lucian Thomas, two unidentified, Bernard Meyer, Paul Kline-Kracht, Kenny Stephenson, Tommy Schneider, unidentified, and John Kelleher. Sister Vitalis stands at back. (Courtesy of Margie Drane Hoferkamp.)

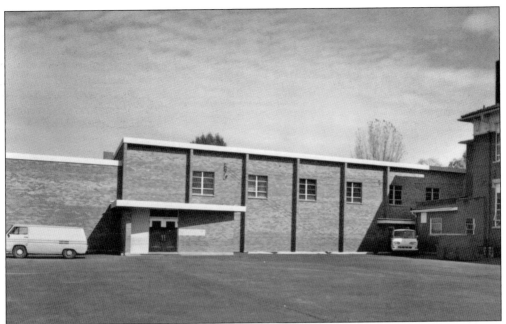

This is the new gymnasium, which was completed in 1962 at 1103 East Kentucky Street. When the church was undergoing renovation and repairs, the congregation used the gym for services. (Courtesy of the Archdiocese of Louisville.)

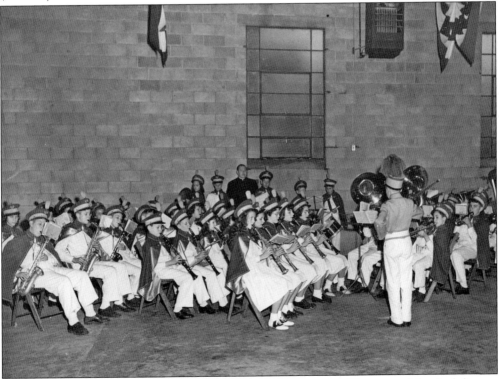

The St. Thérèse School Little Flower Band performs at a concert. (Courtesy of the Archdiocese of Louisville.)

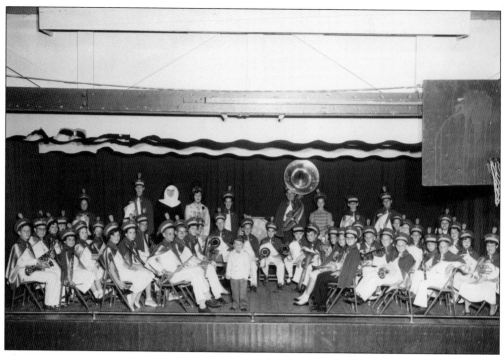

The St. Thérèse School Little Flower Band is pictured here on the stage in the old gym. (Courtesy of the Archdiocese of Louisville.)

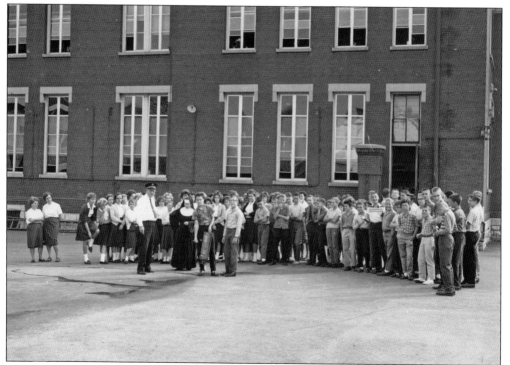

Sister Ethel and a Louisville fireman instruct the sixth, seventh, and eighth graders on the playground in a fire-safety practice in 1963. (Courtesy of the Archdiocese of Louisville.)

The chapel would undergo extensive change during the Vatican II renovations. This photograph shows the original chapel prior to renovation. (Courtesy of the Archdiocese of Louisville.)

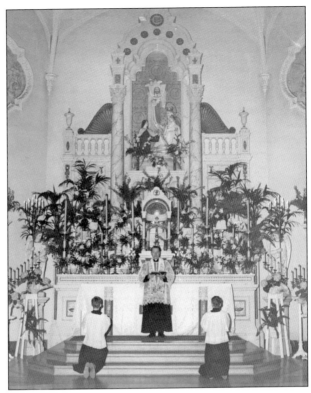

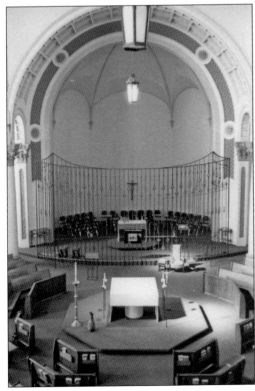

The new sanctuary after the Vatican II renovations was very modern and sophisticated. The altar was brought out into the center to be closer to congregants. While modern and elegant, many elements of the old-world chapel still remained. (Courtesy of the Archdiocese of Louisville.)

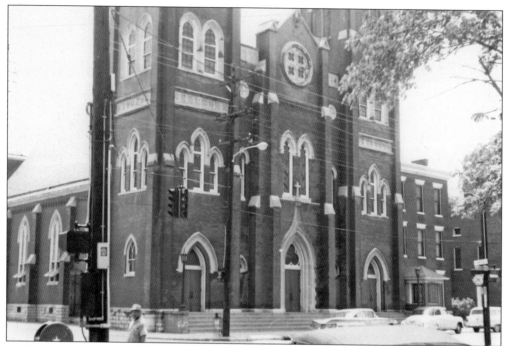

Fr. Herman H. Plaggenborg founded St. Vincent de Paul in 1878. The first church was built at the corner of Milk and Chester Streets on March 31, 1878. The primarily German-speaking parish grew fast, and soon there was need for a larger building. The corner of Shelby and Oak Streets became the new home of the parish in October 1888. (Courtesy of the Archdiocese of Louisville.)

A small store stood on an adjacent lot across from the first church building. This small store was remodeled and served as the rectory for Father Plaggenborg. In 1866, Father Heising remodeled the small store, adding a three-story brick addition to the front. After his death, Father Ohle added another three-story brick addition to the structure. (Courtesy of the Archdiocese of Louisville.)

The St. Ursula Home was built in 1914. Before the construction of the home, the Ursuline Sisters lived in a two-story brick house on Logan Street. Sisters Bartholomew, Isabelle, Felix, and Agatha were the first Ursuline Sisters to teach at the school, because they spoke German, the native language of the majority of the students. (Courtesy of the Archdiocese of Louisville.)

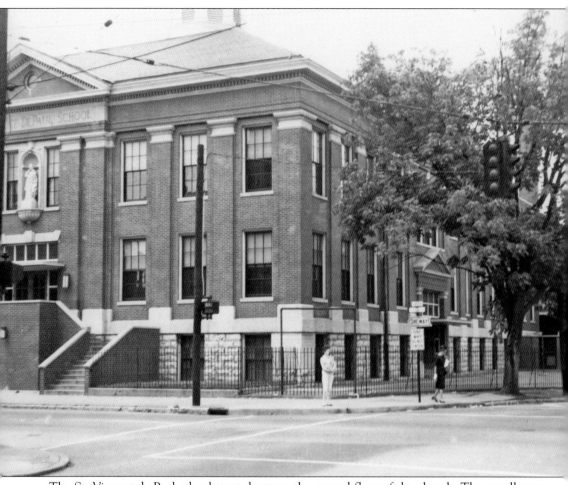

The St. Vincent de Paul school started out on the second floor of the church. The enrollment grew, and five separate buildings were being used for school purposes. In 1910, ground was broken for a new school on the corner of Shelby and Oak Streets. The school was completed in 1911. The Ursuline Sisters taught classes. (Courtesy of the Archdiocese of Louisville.)

Four

SCHOOL AND SPORTS

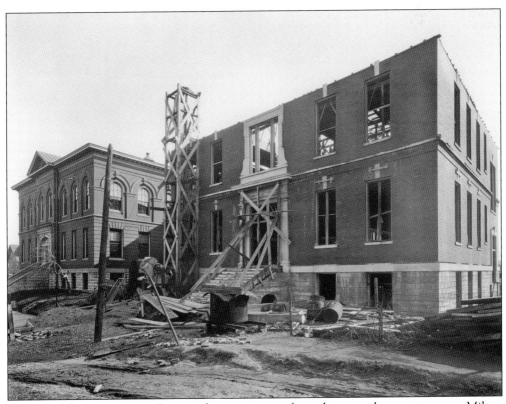

Emerson School was originally started in a two-story frame house and two cottages on Milton Avenue. Elsie Weibel succeeded Miss A. M. Meehan, the first principal, in 1913. (Courtesy of the University of Louisville Photographic Archives.)

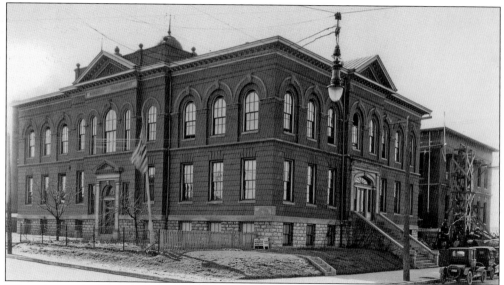

When the new building was constructed in 1923, it was first known as Sylvia Avenue School, then the John Hoertz School, then finally, Emerson School. Emerson School was the name chosen by the students. (Courtesy of the University of Louisville Photographic Archives.)

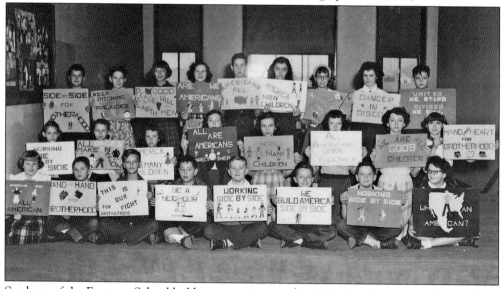

Students of the Emerson School hold patriotic signs in this 1952 class photograph. Pictured are, from left to right, (first row) Carol Hetzel, unidentified, Tommy Ennis, Jim Gross, Gerald Kerr, Bruce Stivers, Henry "Hank" Conn, and Margaret Morton; (second row) Ann Obritsky, Martha Woolet, Patricia Shake, Patricia Inman, Martha Godby, unidentified, Janice Dwyer, and Margaret Swann; (third row) Leslie Goff, Marsha Winstel, Joyce Melvin, Diane Ballard, David Ballard, Sandra Doelker, Gloria Sawtelle, Barbara Zurschmeide, and Frank Kolb. Distinguished alumni include Henry "Hank" Conn (first row, second from right), who grew up on Reasor Street and graduated from the University of Louisville Speed Engineering School. In 2009, Hank and his wife established the Conn Center for Renewable Energy Research and Environmental Stewardship to study alternative energies like solar and wind power, as well as biofuels, at the University of Louisville. (Courtesy of Don and Janice Haag.)

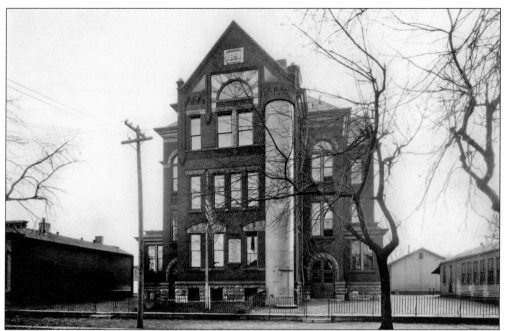

Germantown School started with a small cottage on Swan and Mary Streets. After the purchase of the lot on Mary Street, the main building of the Germantown School was erected in 1891. It was a three-story brick building with 12 classrooms. In this part of the school, classes above the second grade were taught. There are two sixth, two seventh, and two eighth grades in the school. The kindergarten is in a portable building on the site of the original school, and in a separate two-room building, first and second grade pupils have their lessons. (Courtesy of the University of Louisville Photographic Archives.)

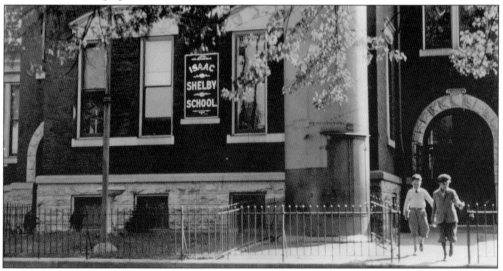

The name of the Germantown School was changed in 1998, when it was named Isaac Shelby in honor of Kentucky's first governor. The name was particularly fitting also because of the school being located near the Shelby Park, the Shelby Branch library, and Shelby Street. The oblong tube pictured in front is a fire escape. At school festivals, "tube rides" were sold for a penny. (Courtesy of the University of Louisville Photographic Archives.)

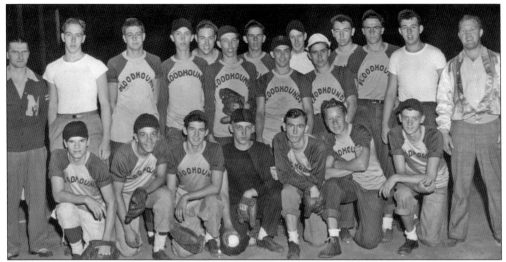

The Bloodhounds Athletic Club of Schnitzelburg existed from 1944 until 1948—only four years, but a wonderful and memorable experience for a group of teenagers who lived in a unique community between World War II and the Korean War. Today most are in their late 70s and early 80s, and some are deceased. However, former Bloodhounds maintain contact and friendship and will say that being a Bloodhound was a highlight of their life. Formed out of an idea for a club by a small group of kids playing ball in the street, the Bloodhounds quickly grew to a self-supporting organization under the adult leadership of Sylvester "Dutch" Kinberger and Harold A. Fow. Their involvement in organized sports and social activities quickly attracted many Schnitzelburg youths, both boys and girls. (Courtesy of Don and Janice Haag.)

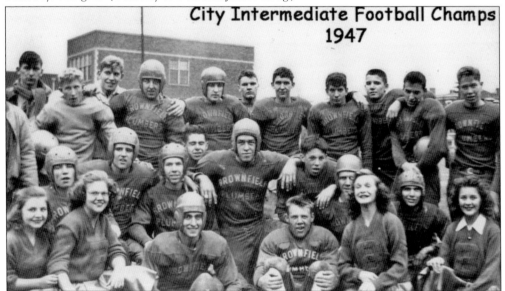

Entering the City of Louisville Recreation Department leagues, the Bloodhounds won the intermediate city fast pitch softball championship in 1946 and the intermediate city football championship in 1947. Brownfield Plumbers sponsored the 1947 football champions. The Bloodhounds also had basketball teams. Meetings and social events were held at the All Wool and a Yard Wide Club. With teenagers growing older, entering the military, attending college, and getting married, the Bloodhound Athletic Club dissolved in late 1948. (Courtesy of Don and Janice Haag.)

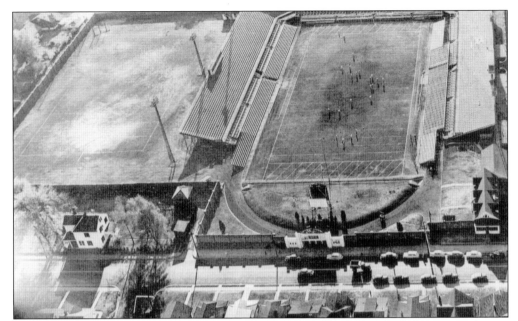

"Milkman's Field," a 6-acre lot in Schnitzelburg, was purchased by the board of education on August 1, 1923. The property had once been leased to cattle owners for their grazing herds. The original Erb farmhouse sits at the bottom left in this photograph. An additional 2 acres was purchased by the board in 1926 for $10,000 and is now known as Kimmel Field. (Courtesy of duPont Manual High School Alumni Association.)

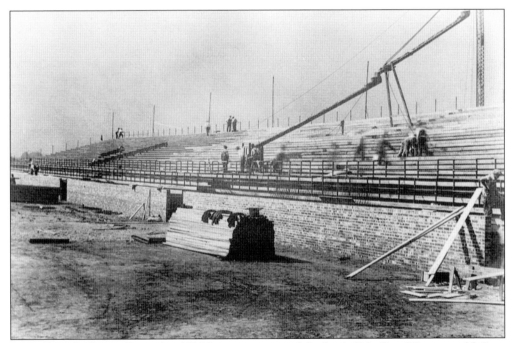

Ground was broken in December 1923 for construction of the football facility. (Courtesy of duPont Manual High School Alumni Association.)

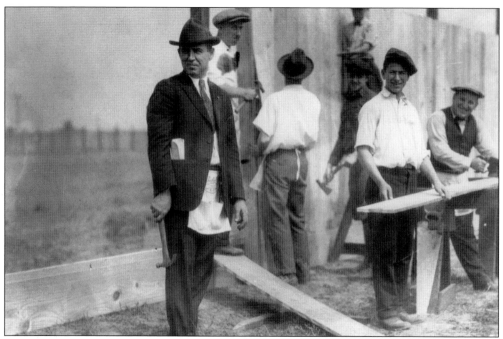

Construction workers are placing a wooden fence around the stadium. (Courtesy of duPont Manual High School Alumni Association.)

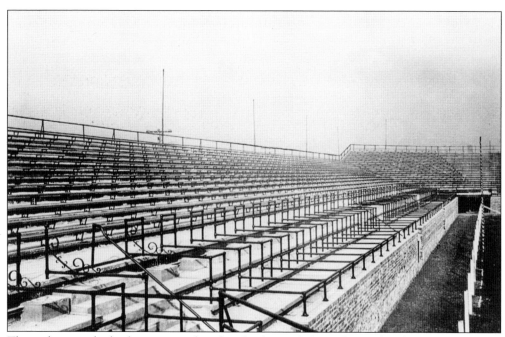

The stadium was built of concrete and steel in the shape of a horseshoe and with a seating capacity of 15,000. (Courtesy of duPont Manual High School Alumni Association.)

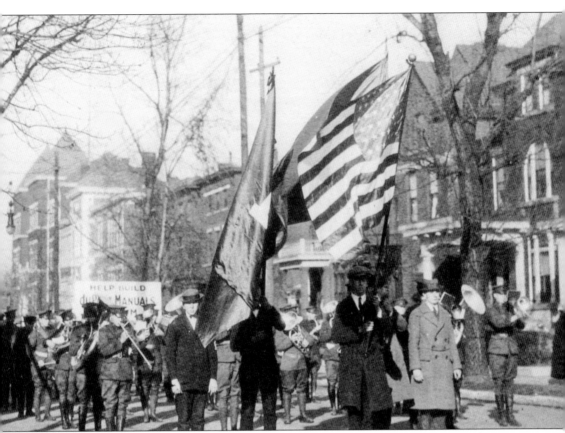

A parade with a marching band and sports teams files down Fourth Street in one of the many alumni fund-raisers for the stadium. (Courtesy of duPont Manual High School Alumni Association.)

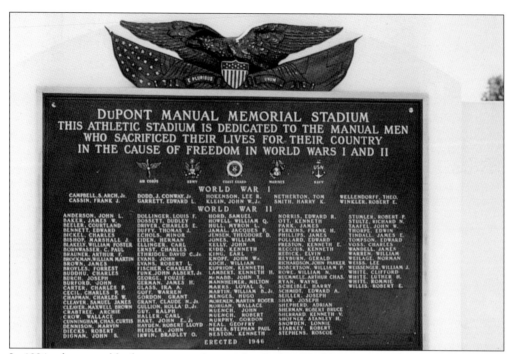

In 1924, a bronze tablet honoring graduates who died in World War I was placed at the stadium. Thus the name was changed to duPont Manual Memorial Stadium. In 1946, a new, larger bronze tablet was installed honoring World War I and World War II Manual war dead. (Courtesy of duPont Manual High School Alumni Association.)

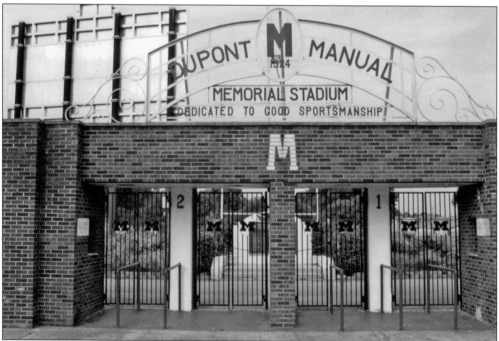

Emblazoned with "Dedicated to Good Sportsmanship," the entrance gates to the stadium have welcomed fans for over 80 years. (Courtesy of duPont Manual High School Alumni Association.)

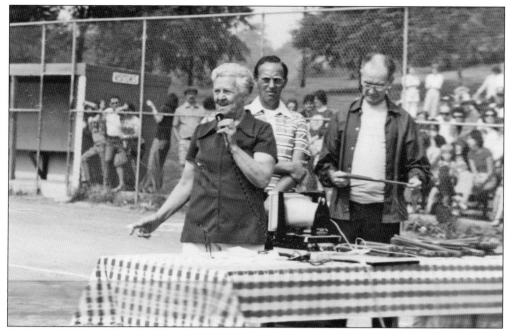

Germantown Baseball's league charter was established in 1952. The original four teams were the Oilers, the Hughes Boys, B&B Motors, and Lone Wolf VFW Post. Founder Mickey Breitenstein had a lifelong passion for baseball. An exceptional ballplayer in her own right, Mickey was the only girl in the neighborhood allowed to participate in the informal neighborhood baseball games, some of which included young hall-of-famer Pee Wee Reese. Mickey is pictured here welcoming the crowd on the 25th anniversary of Germantown Baseball in 1977. (Courtesy of Germantown Baseball, Inc.)

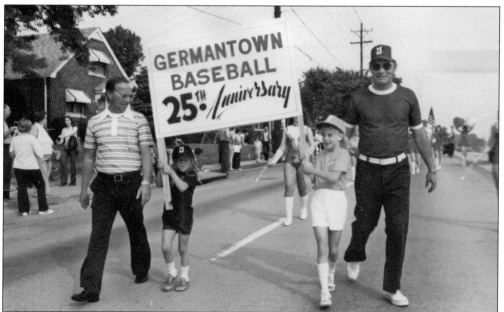

Starting on May 23, 1953, and every year thereafter, the Germantown Baseball opening day begins with a parade. (Courtesy of Germantown Baseball, Inc.)

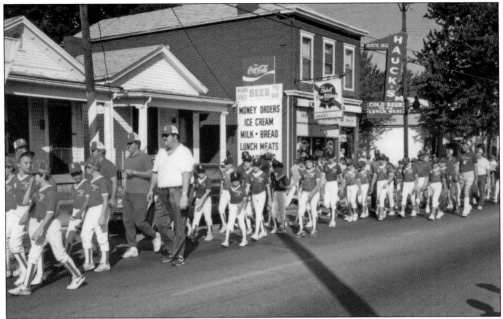

The parade of all teams and sponsors march down Goss Avenue to the ball field, beginning at the Louisville Cotton Mill and Poplar Level Road. (Courtesy of Germantown Baseball, Inc.)

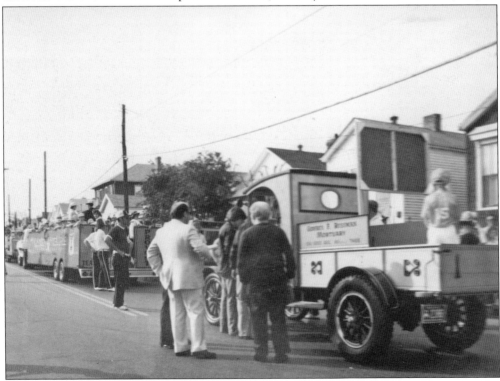

Russman Mortuary and other Schnitzelburg and Germantown businesses participate in the parade with floats and antique cars. The staging lineup for the parade began at McHenry Street. (Courtesy of Germantown Baseball, Inc.)

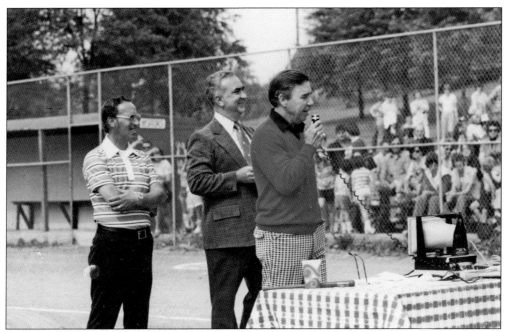

Baseball great Pee Wee Reese would make a number of appearances at the field over the years. From left to right, Ted Berger, Al Fautz, and Pee Wee Reese are pictured here on opening day on the 25th anniversary of the league. (Courtesy of Germantown Baseball, Inc.)

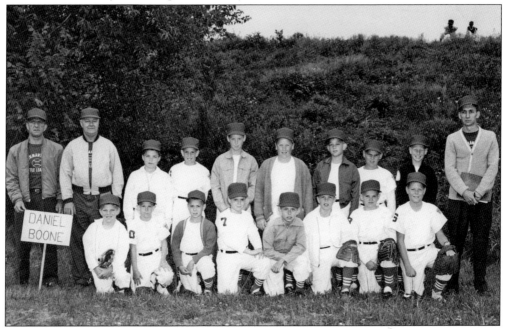

Members of the 1963 Daniel Boone Post No. 1 team are Michael Barnett, John Craig, Glenn Eicher, Bennie Gipson, Dennis Hyberger, Stephen Hyberger, Ronald McClish, Robert Patterson, Sylvester Seadler, David Schank, Steven Schubert, Robert Sims, Gerald Stovall, Gary Tronzo, and Ronald Weir. Coaches pictured are Bud Feusner, Tony Sims, and Don Tronzo (manager). (Courtesy of Germantown Baseball, Inc.)

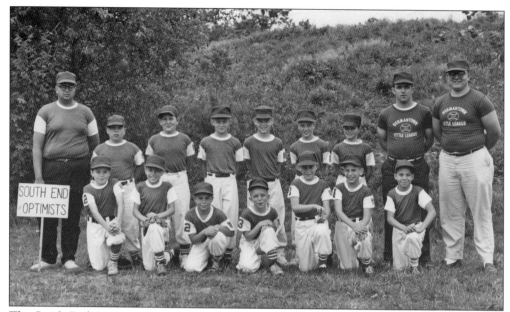

The South End Optimist team players in 1963 are Dennis Blackley, Bobby Cebe, Phil Dattilo, Dennis Fackler, Billy Greene, Doug Gregg, Dean McDonald, Billy Patterson, Bill Raley, Gary Ramser, David Schadt, Jim Stengel, Roy Troklus, Kenny Wall, and Vernon Weickel. Coaches pictured are Larry Kelley and Tom Schadt (manager). (Courtesy of Germantown Baseball, Inc.)

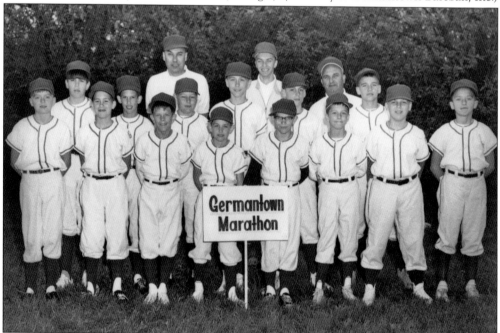

The Germantown Marathon Service team is pictured here in 1963. Players are Mark Allgeier, Chuck Anderson, Tony Ford, Mike Hagan, Chris Heidenreich, Kevin Heuser, John Hornung, Ronnie Kaninberg, Tony Latkovski, Tony Moody, Brian Mullen, Bill Neichter, Tony Passafiume, Terry Riggs, and Richard Voll. Coaches pictured are George Heuser, Bob Kaninberg, and Tom "Skip" Wood (manager). (Courtesy of Germantown Baseball, Inc.)

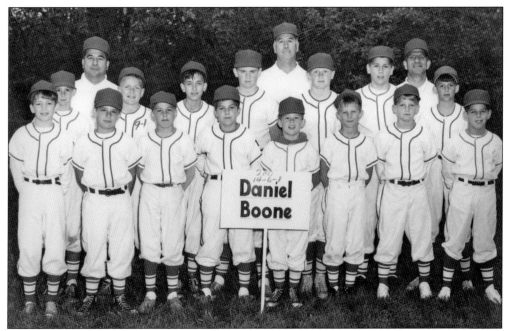

The Daniel Boone Post team, pictured here in 1963, are Mark Baker, Jim Brooks, Mike Cecil, Gus Datillo, Jim Datillo, ? Fleming, Ron Hildenbrand, Bobby Hooe, Terry Meiners, Mark Metzmeier, Mark Showalter, Bobby Tiebens, Dave Tronzo, Dennis Tronzo, and Dave Walls. (Courtesy of Germantown Baseball, Inc.)

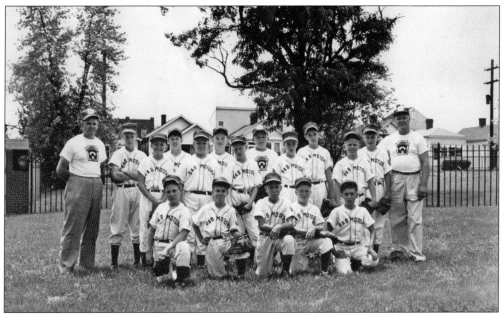

The B&B Motors team is pictured here in an undated photograph. Germantown Baseball was originally played on two diamonds in a field at the end of Samuel Street and Texas Avenue. In 1970, tentative plans were made to extend Samuel Street to Eastern Parkway. A new field was found at St. Xavier High School, and ground was broken for a new field later the same year. (Courtesy of Germantown Baseball, Inc.)

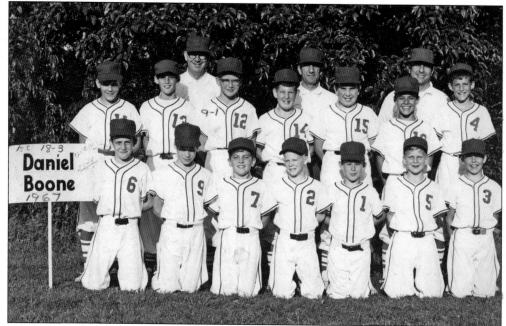

The Daniel Boone Post team members pictured here in 1967 are Guy Campisano, Chuck Casey, Mike Cecil, Gus Datillo, Jim Datillo, Ron Hildenbrand, Bobby Hooe, Zane Kaiser, Mark Metzmeier, Paul Oppel, Phil Reynolds, Mark Showalter, Bobby Tiebens, and Al Tronzo. (Courtesy of Germantown Baseball, Inc.)

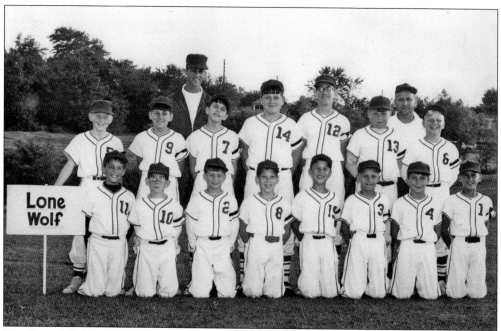

Members of the Lone Wolf Post team in 1968 are Jim Baker, Jeff Bowier, Larry Breit, Mike Bryant, Jerry Buchett, David Craven, Ace Dadisman, Mike Eisenbach, Eddie Gunter, Larry Liebert, Eddie Meyer, Tim Neichter, Daryl Redman, and Dennis Roberts. Coaches pictured are George Hillenbrand, Buzz Lochner, and Hank Meyer (manager). (Courtesy of Germantown Baseball, Inc.)

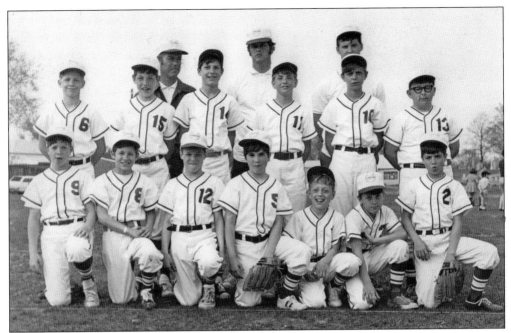

This undated photograph of the Lone Wolf Post team shows team members Tony Anderson, Ricky Elliott, Tim Furlong, David Hubbuch, Thomas Huber, Keith Kern, Danny Ramser, Gary Schwenker, Thomas Seadler, Donald Sewell, Mark Shure, Mike Steele, and Sylvester Tungate. Coaches pictured are J. Craig, L. P. Glass (manager), and G. Hillenbrand. (Courtesy of Germantown Baseball, Inc.)

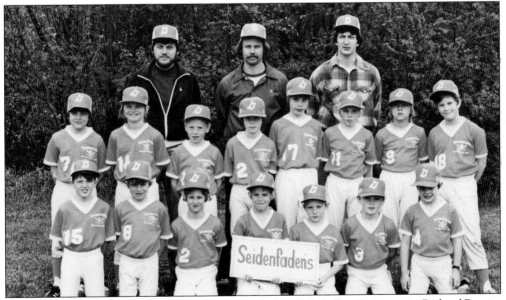

Seidenfaden's Café sponsored this team. Players are Robert Birk, Jeffery Breitenstein, Richard Burgin, Bryan Campbell, William Cecil, Jeffrey Cronin, Thomas Farris, Jeffrey Hall, Craig Hillberry, Roger Kahl, Mark Martin, Damon Massey, Chad Owens, Gary Pollard, Brian Stastney, and Kristopher Wissing. Coaches pictured are Bill Birk (manager), Butch Gavin, and Ron Hildenbrand. (Courtesy of Germantown Baseball, Inc.)

On April 21, 2002, fifty years later, Mickey's vision for a Germantown Baseball league has now become firmly part of the community fabric. Mickey's sons, Jimmy Breitenstein (right), who threw the first pitch on the opening day, and Dicky Breitenstein (left), who was the first catcher, are pictured here on the 50th opening day. (Courtesy of Germantown Baseball, Inc.)

The original players of the Hughes Lumber team pose for a 50th-anniversary reunion photograph. (Courtesy of Germantown Baseball, Inc.)

The original players of the B&B Motors team also reunite for a 50th-anniversary team photograph. (Courtesy of Germantown Baseball, Inc.)

The original Lone Wolf teams gathers for their 50th-anniversary reunion. (Courtesy of Germantown Baseball, Inc.)

The original Oilers team was there to celebrate Germantown Baseball's 50th anniversary. (Courtesy of Germantown Baseball, Inc.)

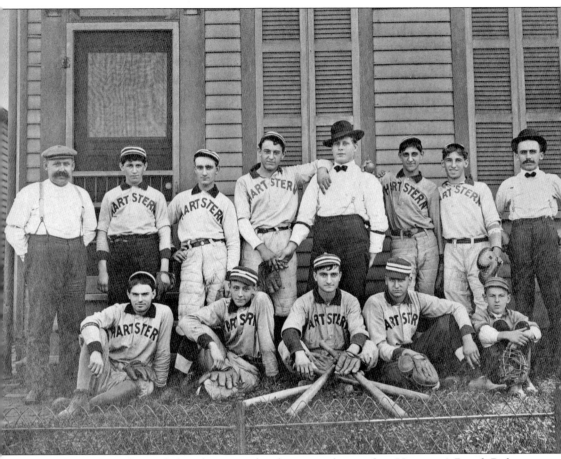

Baseball has always been a beloved sport, and early sponsorships such as Hartstern's Rough Riders entertained the crowds. The Rough Riders are pictured here in front of 930 Ash Street, home of grocer Christ Hartstern and his wife, Bertha. (Courtesy of Steve and Sue-Sue Hartstern.)

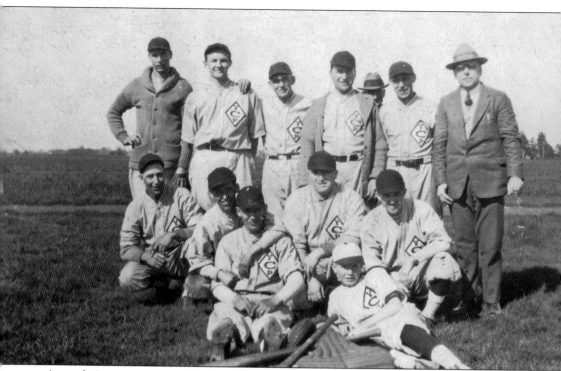

An early "corporate sponsorship" team was the Van Camp's Bean Pole team, pictured here in 1928. Included in this photograph are Bill Albrecht, Clay Cundiff, and Bob Hartstern (Courtesy of Steve and Sue-Sue Hartstern.)

Five

STREET SCENES

While front porches reached high popularity by the early 1900s, not all houses in Germantown and Schnitzelburg had a front porch initially. Porches came later, with community and ownership. In this pre-porch photograph, Gilbert Seng sits on the front steps of 911 Ash Street with his mother, Matilda. (Courtesy of Steve Cambron.)

These interconnecting garages are now almost extinct in Germantown and Schnitzelburg. These rows of tidy garages were once a common sight, as were family vegetable gardens. (Courtesy of Steve Cambron.)

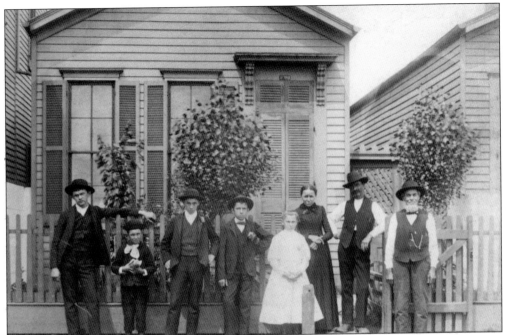

The Haag family stands in front of their home at 937 Goss Avenue around 1887. The large building to the left was J. E. Isert's grocery in the 1890s. Pictured from left to right are George Haag Jr., John Jack Haag, Phillip Haag, Gus Christian Adolph Haag, Louise Haag, Barbara Wiedemann Haag, Johann George Haag, and Christian Gustave Adolph Wiedemann. (Courtesy of Don and Janice Haag.)

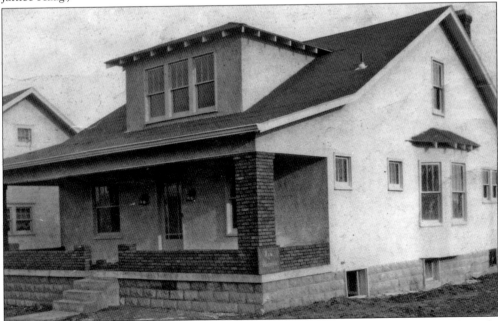

Gus and Cleo Fow built the house at 1044 Wetterau Avenue in 1926. The plaque on the right porch column identifies the house as being at the corner of Ash Street and Wetterau. (Courtesy of Don and Janice Haag.)

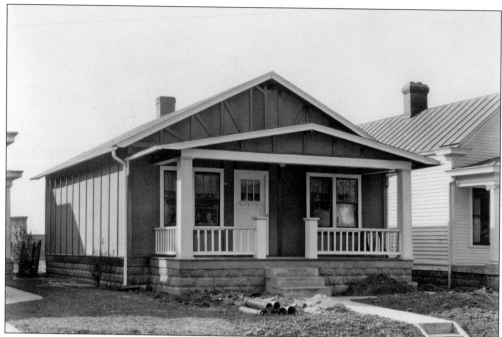

This photograph shows a tidy front view of an exemplary Germantown home at 952 Charles Street in 1922. (Courtesy of the University of Louisville Photographic Archives.)

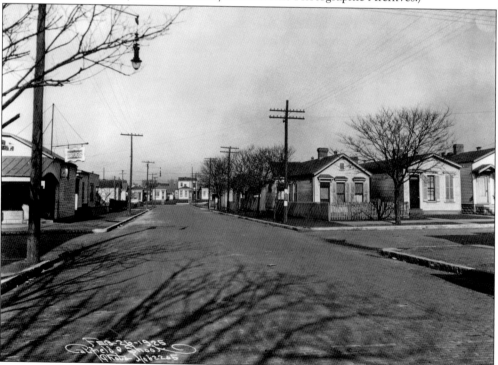

This photograph shows the view of Hickory and Ash Streets in 1925. E. G. Furnow Drugs is pictured to the left. A tidy picket fence surrounds W. L. Anderson's home at 1101 Ash Street on the right. (Courtesy of the University of Louisville Photographic Archives.)

This is an example of the meticulously maintained Germantown/Schnitzelburg home at 1042 Charles Street in 1940. A small sign in front of the house says Unique Beauty Shop. It was common during this time for women to have small businesses in the home, including sewing, ironing, and curtain stretching. In this photograph, the walkway is whitewashed, as was customary in Germantown, and even the window shades are pulled to the exact same length. (Courtesy of University of Louisville Photographic Archives).

George M. Langolf and his German-born wife, Mary Dieplotz Langolf, and their four daughters lived over the Langolf's Grocery at 1153 Logan Street. George grew up over the store at 1153 Logan Street and eventually took over the family business that his father founded. (Courtesy of Carroll Ray Obst.)

Dubbed "the finest home in Germantown," 1059 Cane Street (now St. Catherine) was built by William Mayer of Dickenson Furniture Company around 1884. (Courtesy of Carroll Ray Obst.)

The sidewalk is spotless in front of 840 Ash Street in 1930. No trash or weeds can be found on the unique herringbone brick sidewalk. (Courtesy of the University of Louisville Photographic Archives.)

The Weber Farm at 1477 Texas Avenue was the home of Charles F. Weber and Amelia F. Fischer Weber. (Courtesy of Marife Bautista.)

This photograph shows the newly constructed home at 2320 Dorma Avenue in 1927. This style of home features a sloping drive and underground garage. (Courtesy of the University of Louisville Photographic Archives.)

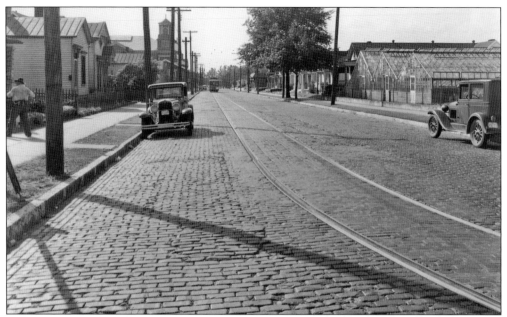

An electric trolley car on the Schnitzelburg Loop is shown here coming up Burnett Avenue and approaching St. Elizabeth's. Leo Zoeller's greenhouses at 1125 Burnett Avenue are pictured on the right. The one-direction streetcar line started at the Shelby Street carbarn, heading east on Burnett Avenue, north on Texas Avenue, and down Goss Avenue back to Shelby Street. (Courtesy of the University of Louisville Photographic Archives.)

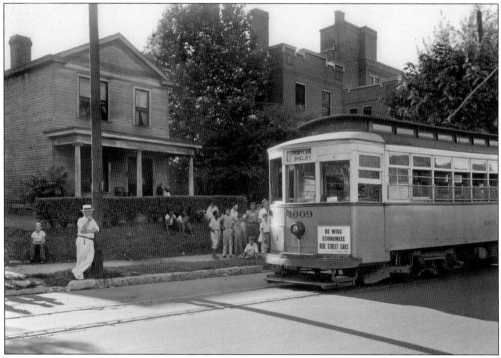

A humorous advertisement to "Be Wise. Economize. Ride Street Cars" is shown on the Portland/ Shelby Streetcar in 1939. (Courtesy of the University of Louisville Photographic Archives.)

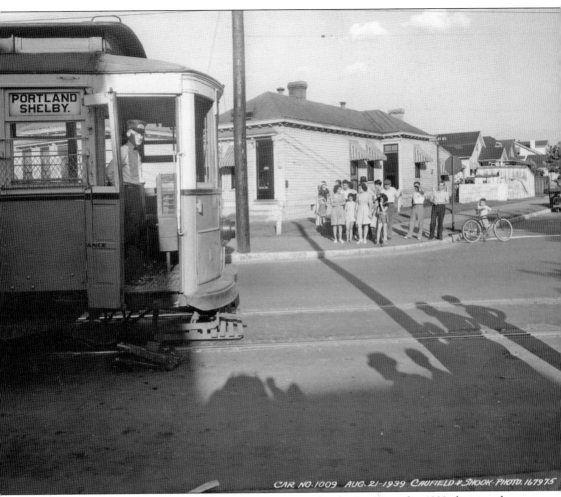

The Portland Shelby Streetcar No. 1009 arrives at Shelby and Lydia Streets in this 1939 photograph. (Courtesy of the University of Louisville Photographic Archives.)

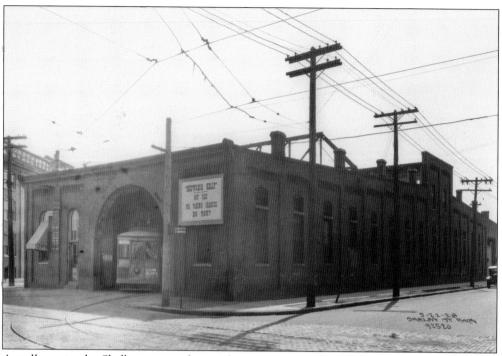

A trolley exits the Shelby street carbarn. The sign on the side of the barn refers to Kentucky's own John "Shipwreck" Kelly, who began his football career in 1931 at the University of Kentucky and was later drafted by the New York Giants. (Courtesy of the University of Louisville Photographic Archives.)

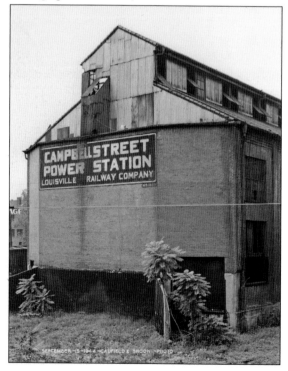

The Campbell Street Power Station electrified the trolleys on the Schnitzelburg Loop. (Courtesy of the University of Louisville Photographic Archives)

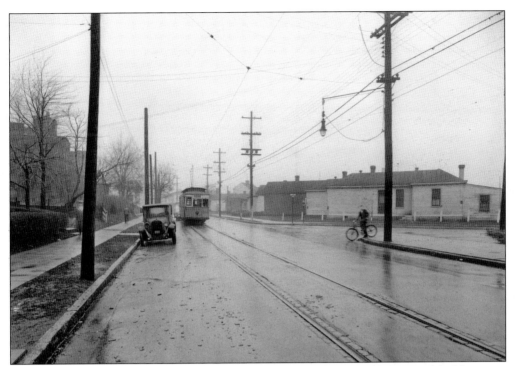

The trolley on Shelby Street approaches Lydia Street in December 1942. (Courtesy of the University of Louisville Photographic Archives.)

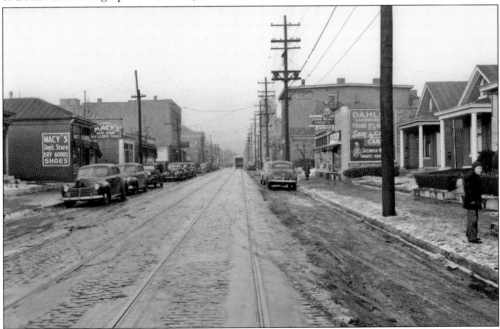

A truck makes it way up Shelby Street just days before Christmas in December 1945. Shown here is 1252 Shelby Street with Macy's Department Store on the left. The next two-story building on the left is Hy Klas Paints. Dahlem's Hardware is on the right at 1249 Shelby Street. (Courtesy of the University of Louisville Photographic Archives.)

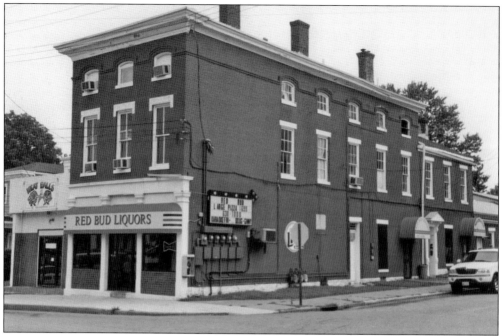

The building at 983 Goss Avenue is shown here in one incarnation as Red Bud Liquors. This historic building was once home to the Great A&P Tea Company in 1937. (Courtesy of Carroll Ray Obst.)

Ellison Avenue developed later than the rest of Germantown. Housing styles changed in the meantime, as in the example of 1210 Ellison Avenue, pictured here in 1956. (Courtesy of the University of Louisville Photographic Archives.)

Margie Drane Hoferkamp is pictured in front of the home of her parents, John and Blanche Drane, at 925 Schiller Avenue in 1943. Behind Margie is the bricked road leading up to Breckinridge Street. (Courtesy of Margie Drane Hoferkamp.)

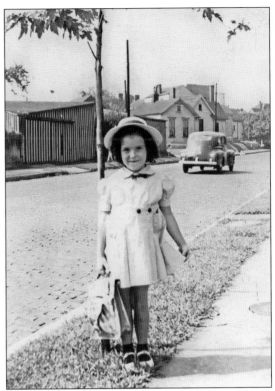

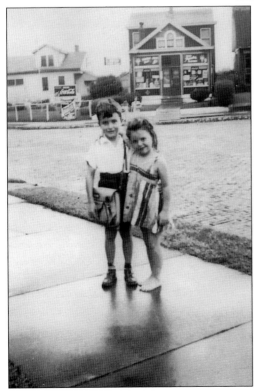

Margie Drane and her brother Danny stand outside the old Pfeiffer's Grocery on Schiller Avenue. (Courtesy of Margie Drane Hoferkamp.)

This photograph shows the 1934 view of the 1000 block of Charles Street looking toward Spratt Street. (Courtesy of the University of Louisville Photographic Archives.)

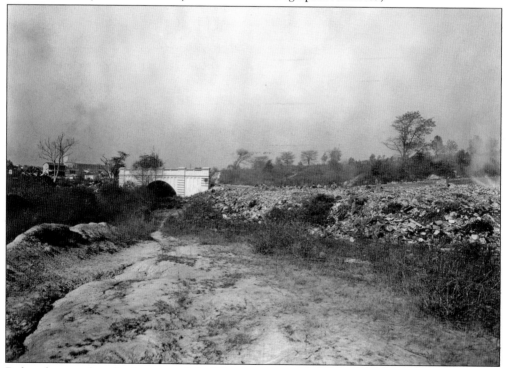

Before the complete development of the Ellison section of Germantown, trash was disposed of at this landfill. (Courtesy of the University of Louisville Photographic Archives.)

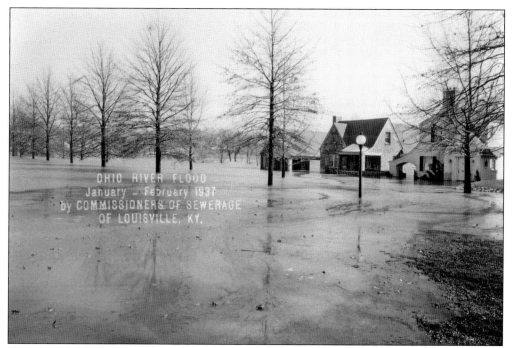

This photograph shows high floodwaters at the intersection of Eastern Parkway and Goss Avenue. (Courtesy of the University of Louisville Photographic Archives.)

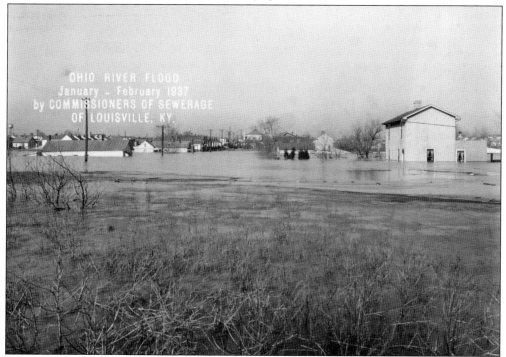

The home on the left, on Schiller Avenue looking from Ellison Avenue, is submerged almost up to the roofline. St. Thérèse is pictured in the background. (Courtesy of the University of Louisville Photographic Archives.)

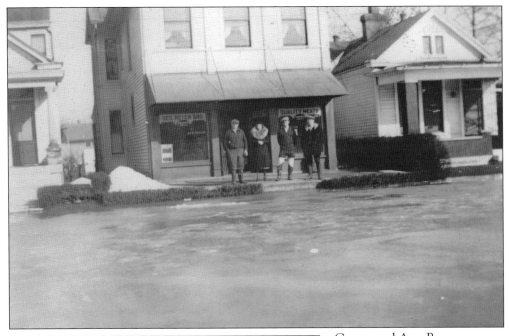

George and Ann Royer stand outside their grocery store at 1097 East Kentucky Street. (Courtesy of the Archdiocese of Louisville.)

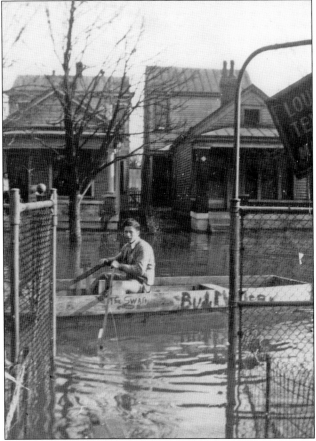

John L. Lee paddles his boat, *The Swan*, down McHenry Street toward Goss Avenue. Lee may have used this boat to deliver canned goods to neighboring families until the floodwater resided and grocers could restock. (Courtesy of Justin Lee.)

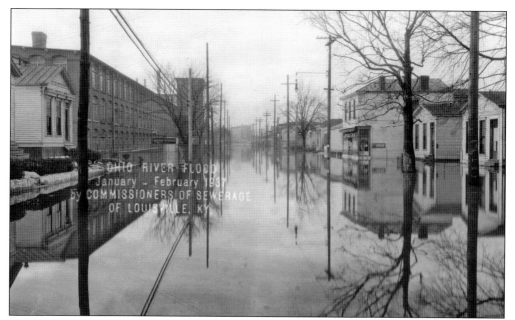

Floodwaters are shown here at Goss Avenue and McHenry Street near the Louisville Textile Mill. Ollie Rickert's home was on the left at 948 Goss Avenue. The business at 953 Goss Avenue, pictured on the right, was Metzler's Bakery. (Courtesy of the University of Louisville Photographic Archives.)

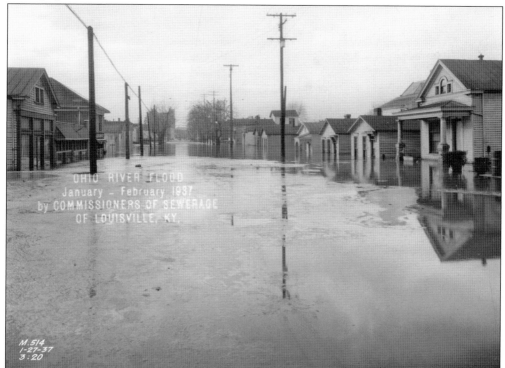

This photograph shows floodwater levels at Oak and Swan Streets, looking west. (Courtesy of the University of Louisville Photographic Archives.)

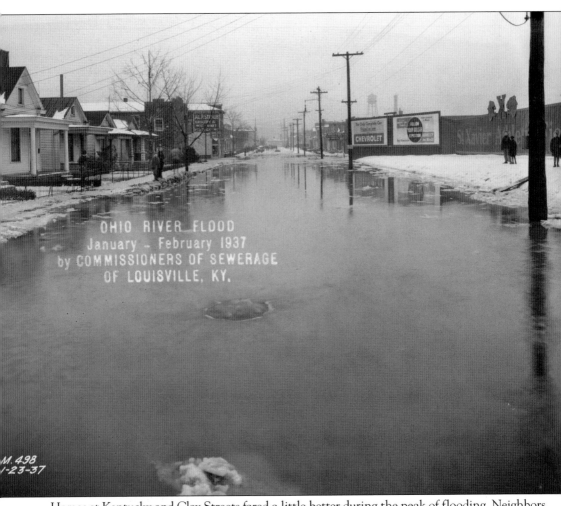

Homes at Kentucky and Clay Streets fared a little better during the peak of flooding. Neighbors stand on each side of the street in this photograph. (Courtesy of the University of Louisville Photographic Archives.)

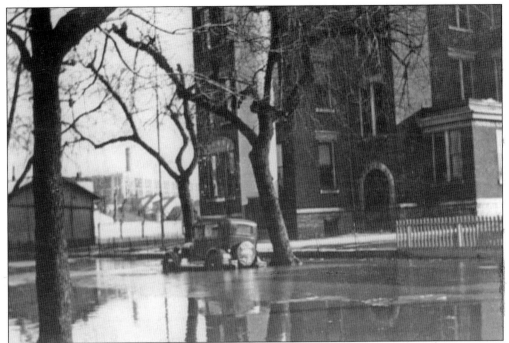

Henry Walter, an employee at Shelby Elementary School, took this photograph of the high floodwater at the school. (Courtesy of the Henry Walter family.)

Ruff's Grocery stood at the corner of Krieger and Edison Streets. Robert Ruff is pictured here as a boy. He operated a hardware store at this location until 2003. (Courtesy of Tammy Jones-Scrogham.)

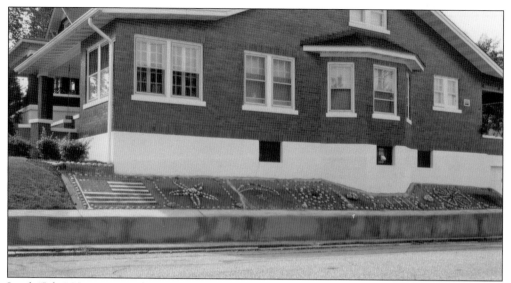

Jacob "Jake" Hartstern, a pharmaceutical representative, lived at 1268 Goss Avenue. He built this home for his wife, Rose, in the late 1920s. Jacob was beloved in the community and was known for helping newly arriving German settlers with immigration paperwork, asking only for a democratic vote in return. This mural is believed to have been installed by Jake at 1268 Goss Avenue around 1933. It is a well-known community landmark today. Jake Hartstern maintained the American flag's field of stars by means of a stencil. In 1959, he had to reconfigure the field with 50 stars when Alaska and Hawaii became the 49th and 50th states respectively. (Author's collection.)

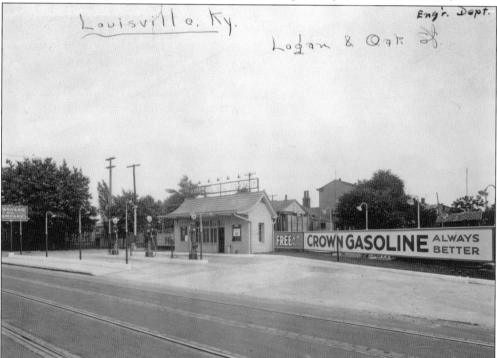

Gas was being sold for 18¢ per gallon at Standard Oil Crown Gasoline station at Logan and Oak Streets. (Courtesy of University of Louisville Photographic Archives.)

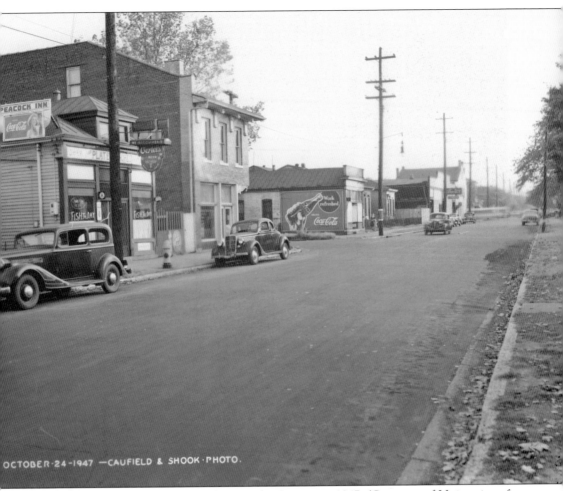

OCTOBER·24·1947 —CAUFIELD & SHOOK·PHOTO.

The Peacock Inn stood at Logan and Kentucky Streets in 1947. (Courtesy of University of Louisville Photographic Archives.)

www.arcadiapublishing.com

Discover books about the town where you grew up, the cities where your friends and families live, the town where your parents met, or even that retirement spot you've been dreaming about. Our Web site provides history lovers with exclusive deals, advanced notification about new titles, e-mail alerts of author events, and much more.

Find Your Place in History.